Van Gogh's
Second Gift

VAN GOGH'S SECOND GIFT

A Spiritual Path to Deeper Creativity

Quotations from Vincent van Gogh's letters appear by permission from
Vincent Van Gogh: The Letters: The Complete Illustrated and Annotated Edition.
Edited by Leon Jansen, Hans Luitjen, and Nienke Bakker. 6 volumes.
London: Thames and Hudson, in association with the Van Gogh Museum
and the Huygens Institute, 2009. An expanded version of the printed edition
is available free of charge at www.vangoghletters.org.

Permission to reproduce photographs of letters and artworks was procured from
Vincent van Gogh Foundation/National Museum Vincent van Gogh, Amsterdam.

Cover image: Van Gogh self-portrait (1889)
Cover design: James Kegley

Print ISBN: 978-1-5064-6235-6
eBook ISBN: 978-1-5064-6236-3

Van Gogh's Second Gift

A SPIRITUAL PATH TO DEEPER CREATIVITY

CLIFF EDWARDS

Broadleaf
Books

Contents

The Illuminations

Van Gogh's Two Gifts

Van Gogh's First Gift

Vincent van Gogh left us two extraordinary gifts. The first is available to us through the collection of his now-famous paintings hanging in the world's museums and displayed in hundreds of art books that contain reproductions of his works. Perhaps one such painting is featured as a bright image on your coffee cup. My guess is that at least one of his paintings came to your mind as you picked up this book with the name "Van Gogh" on its cover. A few years ago you might have thought about his *Wheatfield with Crows*, the golden wheat pushed by the winds, a stormy sky of deep blues above, thirty or more black crows in flight, and three farm paths of brown earth and green grass leading through and around the wind-blown grain. This was perhaps the most famous painting in the Van Gogh exhibit that toured the United States in 1998 and 1999. Or perhaps you thought of one of his sunflower paintings displayed on posters in homes and dormitories around the world.

New favorites develop over time. With the popularity of Don McLean's song "Starry, Starry Night," Van Gogh's painting *Starry Night*, with its swirls of stars, became popular. And with the opening scene of the "painted" film *Loving Vincent*, audiences were immersed in the vibrant starry sky of that painting and then dropped to earth in Van Gogh's neighborhood in southern France. From there, the film told the dramatic story of the artist's life and

2

death through the memory of those who knew him. When we think of Van Gogh, we think of specific images.

But, of course, Vincent's first gift was not simply the collection of painted canvases. It was actually his *vision.* His unique way of seeing confronts us in those canvases: Vincent's eyes and the choices they led him to favor—the places and people he attended to, the way he saw, and how he stroked his canvas with forms and colors. His vision rested on a particular asylum garden, on specific fields and laborers, on that mother in that rocking chair holding that child. He offered us his eyes, his view of specific moments and places in nature, his experience focusing on particular persons. And he painted what he saw with the feelings he believed would resonate with our lives as they did with his. Through his eyes we see the corners of the world he felt needed attention, often the most available yet most ignored scenes and moments in the lives of ordinary people. It is his unique view of the world that we see, for example, in his letter to his brother Theo, likely written July 21, 1882: "Even though I'm often in a mess, inside me there is still a calm, pure harmony and music. In the poorest little house, in the filthiest corner, I see paintings or drawings. And my mind turns in that direction as if with an irresistible urge" (Letter 249).

The singularity of that vision in Van Gogh's search for a new approach to art is what the famous artist Picasso tried to describe to the art world with these words:

> Beginning with Van Gogh, however great we may be, we are all, in a measure, autodidacts—you might almost say primitive painters. Painters no longer live within a tradition and so each of us must recreate an

entire language. . . . And the individual adventure always goes back to the one which is the archetype of our times: that is, Van Gogh's—an essentially solitary and tragic adventure.

Picasso's description of the adventure of discovering a new way of seeing and doing art is at the heart of this book, which shares aspects of Vincent van Gogh's adventure of creative and spiritual pilgrimage expressed through intimate letters to his younger brother, Theo, and to others close to him. These words that describe this adventure of discovery are at the heart of Vincent's second gift.

Van Gogh's Second Gift

Van Gogh's first gift, his way of seeing and thus living his art, is distinctly lodged for us in his paintings. But it tells only half of the Van Gogh story. The second gift—the gift of his writings—is the focus of this book. The gift expressed in his letters is even more mysterious than the first gift, though the two are closely entwined and often experienced together. The second gift lives within an amazing collection of letters written by and to Vincent during his brief thirty-seven-year life. The voluminous collection—more than a thousand letters amounting to almost four thousand pages— may make this gift appear far less accessible than the gift of his paintings. But unlike the paintings, what is included in Vincent's intimate letters was not intended for our viewing at all. And our examination of these letters would have surprised, puzzled, and maybe even embarrassed the artist. Yet, as with his art, we hope to go deep within the letters his family and friends have offered

us to find the heart of this second gift: Vincent's reflections and insights on the joys and sorrows of a life lived creatively.

The letters give us a window into this singular artist. And with the artworks and letters combined, we discover a new approach to both seeing and doing, and an individual's adventure in the quest for the meaning of life.

To seek the heart of these letters is to see Vincent's struggle at its deepest level, the level of his spiritual search. In many ways, his new way of seeing and doing art, as evidenced in the paintings, is paralleled by his new way of viewing the world, living his quest for a new language of the spirit, and applying that to his daily life. Vincent's letters, when we search diligently, have hidden in them the passionate creativity displayed in the best of his art, and when we apply their wisdom, they offer us a new language for humanity's search for creative and meaningful living.

Access to Vincent's Spiritual Quest through the Letters

As we read through the personal letters of Vincent van Gogh, we find that a special sort of concentration, a meditative attentiveness, is required. And because the letters span several thousand pages, we may need some sort of entrance ramp to the collection's creative words. This book, I trust, will be that bridge. Here I provide brief, pointed passages selected from Vincent's letters. I also offer a short description of a given letter's setting and suggest something of the meaning within, related to Vincent's own experience. My hope is that among these passages you will find some that speak directly to you. You might find yourself intrigued about the nature of Vincent's

own quest, the relation of his spirituality to his art. You might even begin to view him as a spiritual guide. Perhaps you will find in him what that famous Dutch psychologist, theologian, and priest, Henri Nouwen, called "my wounded healer," claiming Vincent as his hidden spiritual guide.

When you find passages from Vincent's letters that intrigue or move you, I hope you'll be inspired to explore the entire letter containing the given passage, or to continue searching his correspondence for yourself. Alongside each passage, I provide the number scholars have assigned to that letter. The entire collection of letters is now easily accessible on the internet at vangoghletters.org. Made available in 2009 by the Van Gogh Museum in Amsterdam along with the Huygens Institute, the website also provides facsimiles of each letter in its original language, generally Dutch or French, alongside a new English translation. For those who love digging deeper, you can also see scholarly annotations on letters and view paintings and drawings mentioned in each letter. This book is a starting point, an introduction to Vincent's second gift. If you spend time with the letters online, you'll see that they contain many more insights than can be included here on creativity, spirit and landscape, starry nights, paint color, and books to deepen your own creative life. Vincent was always trying to see, learn, connect, look at color, and understand the poetry of the natural world. Through his letters he articulated the inner workings and sources of his creative life; letter by letter, he reveals these profound insights to us.

The Problems and Promises of Letters

Of those almost four thousand pages of letters, Vincent himself

wrote 820, many of them several pages long. Of his letters, 658 were to Theo or, later, to Theo and his wife, Johanna; eighty-three of the letters were from Theo to Vincent. Despite the brothers' closeness, there are still secrets, hidden assumptions, and sensitive topics avoided by one or the other. Recognizing such difficulties is important to our own search through the letters. And the fact that some of the original correspondence was lost or destroyed means there are gaps that only thoughtful attention might possibly help us fill.

Though personal letters are becoming more and more a thing of the past, many of us have had experience reading with deep concentration letters sent by family and friends, or letters saved from correspondence over the years. Readers dedicated to Van Gogh's letters might find an interesting surprise in store, as many spiritual and creative insights are woven throughout. Those who already have studied these letters or know something of Vincent van Gogh's biography know about his upbringing in a Dutch Protestant parsonage, where the Bible was read aloud daily and where biblical texts were memorized and interpreted in weekly sermons. You may also know that he served for a time as an evangelist in the mining villages of the Borinage in Belgium, giving lessons on Bible stories and preaching sermons on biblical texts.

For years I have searched in vain for books on Van Gogh that recognize that for years, most of what he pondered from the New Testament was, in fact, letters attributed to the apostle Paul and to individuals or faith communities. These were apparently among Vincent's favorite parts of the Bible, and he returned often to

passages such as the famous portion on faith, hope, and love in the first letter to the Corinthians. Vincent also read the section in the second letter to Corinth where Paul describes the life of discipleship as "sorrowful, yet always rejoicing; as poor, yet making many rich; as having nothing, and yet possessing everything" (2 Cor 6:10). For several years Vincent pondered this passage and quoted it in his own letters at several critical moments in his life.

My own bifurcated studies in art and theology led me to study the letters of the New Testament at length. Little did I know at the time that this would be training for a deep and careful reading of the Van Gogh letters, helping me discover Vincent's years of pondering the biblical epistles, and assisting me in examining his own intentions and strategies in both letter-reading and letter-writing.

The Caregivers Who Delivered Vincent's Letters to Us

One of the most moving accounts of the life of Vincent van Gogh and his relationship with his younger brother, Theo, is available to us in a three-volume set published by the New York Graphic Society in 1958. That account, with its translation of Vincent's letters, was largely the work of Theo's young, widowed wife, Johanna van Gogh-Bonger. Already busy with the care of the son she and Theo had named after Vincent, and struggling to earn a living for herself and the child, she dedicated herself to making available to the world the letters her husband had so carefully preserved.

Theo carefully kept each letter sent to him by Vincent, even the stained one that was in Vincent's pocket when he died in July

1890. Within six months of Vincent's death, Theo himself died at age thirty-three. This left Johanna to decide what was to be done with both Vincent's hundreds of paintings and drawings and the stack of letters Theo had preserved. All could easily have been destroyed as Johanna closed their apartment in Paris and moved back to the Netherlands. But the following excerpts from Johanna's introduction to her own English translation of the correspondence remind us how much we owe to her and Theo for the safekeeping of those fragile writings:

> When as Theo's young wife I entered in April, 1889, our flat in the Cite Pigalle in Paris, I found at the bottom of a small desk a drawer full of letters from Vincent, and week after week I saw the soon familiar yellow envelopes with the characteristic handwriting increase in number. . . .
>
> After Vincent's death Theo discussed with me the project of publishing these letters, but death took him away ere he could begin to execute this plan. . . .
>
> The letters have taken a large place in my life already, since the beginning of Theo's illness. The first lonely evening which I spent in our home after my return I took the package of letters. I knew that in them I should find him again. Evening after evening that was my consolation after the miserable days. It was not Vincent whom I was seeking but Theo. I drank in every word, I absorbed every detail. I not only read the letters with my heart, but with my whole soul. And so it has remained all the time. I have read them, and reread them, until I saw the figure of Vincent before me. . . .

I remember how last year, on the day of Vincent's death, I went out late in the evening. The wind blew, it rained, and it was pitch-dark. Everywhere in the houses I saw light and people gathered around the table. And I felt so forlorn that for the first time I understood what Vincent must have felt in those times, when everybody turned away from him, when he felt "as if there were no place for [him] on earth. . . ." I wish that I could make you feel the influence Vincent had on my life. It was he who helped me to accommodate my life in such a way that I can be at peace with myself. Serenity—this was the favorite word of both of them, the something they considered the highest. Serenity—I have found it. Since that winter when I was alone, I have not been unhappy— "sorrowful yet always rejoicing," that was one of his expressions, which I have come to understand now.

Illuminations: Creative Encounters with Vincent van Gogh's Letters

The passages included in this book are chosen from the pages of the Van Gogh correspondence. I hope each selection offers you a creative encounter with Vincent van Gogh and his explorations of the world. His intimate words to Theo, a few other family members, and comrades in the arts offer unique access to Vincent's moments of discovery related to spirituality, the arts, nature, friendship, love, suffering, and joy.

You may think of each passage as an attempt by Vincent to solve one of life's mysteries, to comfort another struggling human being, or perhaps to reflect on a luminous moment of meditative

awareness as he painted, contemplated his task as an artist, or sought to encourage family, friends, and fellow artists. I call the passages "illuminations" as they so often focus on the dark corners of the world that Vincent felt were often forgotten and most in need of comfort and encouragement, and where he offered his own penetrating light.

Perhaps as you read and explore Vincent's insights—the illuminations—you will see the figure of Vincent and receive some gift comparable to the one Johanna van Gogh-Bonger received. Further, I hope that an Illumination from among the letters will spread its light to some of Vincent's paintings that have already become your favorites, or that may have puzzled you over the years, and perhaps his own profound creative search will inspire or guide your journey. To that end, I've crafted a short section following each Illumination with notes for your reflection and creative engagement.

Illustrations: An Expressionistic Encounter

Just as the illuminations are in chronological order, so I have listed the sketches in chronological order at the end of the book. The illustrations are seldom from the same letters as are found in the body of the text. Vincent's images had various meanings, most often extending a letter's words to show Theo or others what he was seeing or had just painted or was planning to paint. Because the illustrations are meant to illumine, as it were, the wider arena of Van Gogh's letters, they are placed throughout the book more impressionistically, rather than in relation to specific letters or themes. As such, they add another dimension, half writing and half artwork, as they often were in Vincent's letters.

The
Illuminations

Find Things Beautiful as Much as You Can

The first letter preserved from Vincent to Theo (Letter 001) was sent from The Hague in Holland in 1872, where Vincent was newly employed at the international art dealer, Goupil and Company, through the influence of his Uncle Vincent, a partner in the firm. At age sixteen, the younger Vincent wrote a few lines to his schoolboy brother, Theo, age twelve, remembering fondly the few days they had just spent together.

Two years and a dozen letters to Theo later, both brothers are working for Goupil at two different branch offices, and Vincent is now seeking to advise and reassure Theo that things will go well for him in this wonderful art business. In his letter, Vincent gathers that advice and spiritual support in a form he feels Theo will find familiar and welcome. The brothers having been steeped in the language of the Bible from their youth, Vincent echoes it in how he expresses his desire to speak with Theo face-to-face, and in how he offers heartfelt advice grounded in a spontaneous

13

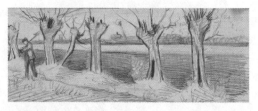

list of artists he admires — including many who are often forgotten or attacked rather than appreciated — all regarded by Vincent as mentors. Finally, he returns to a note of essential wisdom.

In its low-key way, the letter reveals Vincent's concern for Theo and a confidence in the arts, artists, and nature as teachers. Vincent reminds Theo to open himself to beauty, though he reflects that too few people do so. As we read Van Gogh's letters, we are reminded to do the same — to walk in the world, as taught by artists, with eyes to see beauty and love nature; to appreciate the lives and work of others that lead us to beauty and remind us to be open and generous.

Emphasis shown in this and other letters is original. In another translation of this passage, Johanna van Gogh-Bonger provides a gracious alternative wording: instead of "*find things beautiful* as much as you can," she renders the sentence, "*Admire* as much as you can; *most people do not admire enough*."

This openness to and gratitude for the gifts of others is an ongoing theme in Van Gogh's life. It is often revealed in dialogical tension with his self-enforced "aloneness" and failure to find reliable companions to share his vision of a new and cooperative art sensitive to nature and the oppressed. But it's clear through the letter and the long list of artists that Vincent has a sense for which creative companions support and stretch his own thought and words — and that these are an integral part of his own "find[ing] things beautiful as much as [he] can."

Vincent to Theo, Letter 017

London, January 1874

How I'd like to talk to you about art again, but now we can only write to each other about it often; *find things beautiful* as much as you can, most people *find too little beautiful*.

I'm writing below a few names of painters whom I like very much indeed. Scheffer, Delaroche, Hérbert, Hamon. Leys, Tissot, Lagye, Boughton, Millais, Thijs Maris, Degroux, De Braekeleer Jr.

Millet, Jules Breton, Feyen-Perrin, Eugène Feyen, Brion, Jundt, George Saal. Israëls, Anker, Knaus, Vautier, Jourdan, Jalabert, Antigna, Compte-Calix, Rochussen, Meissonier, Zamacois, Madrazo, Ziem, Boudin, Gérôme, Fromentin, De Tournemine, Pasini.

Decamps, Bonington, Diaz, T. Rousseau, Troyon, Dupré, Paul Huet, Corot, Schreyer, Jacque, Otto Weber, Daubigny, Wahlberg, Bernier, Emile Breton, Chenu, César de Cock, Mlle Collart. Bodmer, Koekkoek, Schelfhout, Weissenbruch, and last but not least Maris and Mauve.

But I could go on like this for I don't know how long, and then come all the old ones, and I'm sure I've left out some of the best new ones.

Always continue walking a lot and loving nature, for that's the real way to learn to understand art better and better. Painters understand nature and love it, and *teach us to see. . .*

For Reflection

What things do you find truly beautiful? Can you name at least one such beautiful thing you have experienced today? You might begin with the smile of a child, the excitement of a pet, a simple landscape, a quiet corner, something said by a friend. Did you respond to those moments, express thanks for them, share them with others? How might Vincent's enthusiasm in naming over sixty artists whose work he found beautiful lead you to open more widely your own sense of beauty and acknowledge its power to deepen your life?

For Creative Engagement

Make a list of beautiful moments you have experienced today. Commit to setting aside a time at the end of each day to search out such moments. Focus on even the simplest of such moments and express your thanks on paper, in paints, or in some other way related to your creative life. Imagine some way in which that beauty can be shared with another person tomorrow. See if you can find an encounter with beauty that asks of you what an encounter with a beautiful art object asked—even insisted—of the poet Rainer Maria Rilke: "You must change your life."

Remember, You Are a Pilgrim and Life Is a Long Walk

After a strong start in the art business at Goupil and Company, Vincent was suddenly and surprisingly asked to resign effective April 1, 1876. His insistence that he be allowed to return home for the Christmas holidays may have been a factor, but his unhappiness with being transferred to the Paris branch of the company and his seclusion in a Montmartre room with his Bible and a "disciple" named Gladwell may have added to his superiors' displeasure. Vincent had obviously been moving in the direction of his father's work in ministry. Nevertheless, he was shocked at the loss of his job in France. While he advertised for a church-related position in newspapers in England, what he found was a teaching job that gave him only room and board at a Mr. Stokes' school for boys. However, he soon moved from that to a more suitable post at the Reverend Jones's school in Isleworth, where he assisted a Wesleyan Methodist minister at several small churches outside London. He now saw himself solidly on course

to Christian work related to his father's profession. He soon wrote Theo, "Mr. Jones has promised me that I won't have to teach so much any more, but that I may work in his parish from now on, visiting people, talking to them, and so on. May God give this his blessing" (Letter 093). Within a month he was excited that Rev. Jones had allowed him to preach in one of the small churches. On November 3, 1876, he wrote, "Theo, your brother spoke for the first time in God's house last Sunday, in the place where it is written 'I will give peace in this place'" (Letter 096, November 3, 1876). Vincent enclosed the full text of the sermon he had preached, based on Psalm 119:19, "I am a stranger in the earth: hide not thy commandments from me" (KJV).

Vincent's excitement about his church-related work would be rather short-lived. Likely his father and uncles felt that serving an English Wesleyan Methodist pastor in impoverished parishes for barely any salary was not fit work for a Van Gogh, and so called him home. Several further "failures" to live up to his family's expectations were to follow until, with Theo's encouragement,

Vincent took up his pencil and taught himself to draw at age twenty-seven. His art career spanned only a decade due to his untimely death.

In the portion of the sermon quoted below, already we see themes of mother, father, home, and the quest for a resolution of the antitheses in life, the

coincidence of opposites that can be found in Vincent's search for meaning. Another lifetime theme, that he was a "stranger" on the earth and a pilgrim with "secret chambers in his heart," was also present in his musings. It was the restless, relentless search for deeper spiritual meaning that became the beginning of taking up the pencil, allowing him to explore in a physical, visual way the chambers of the heart.

Opening of Vincent's first sermon, recorded in Letter 096, to Theo

Isleworth, November 3, 1876

It is an old faith and it is a good faith that our life is a pilgrim's progress—that we are strangers in the earth, but that though this be so, yet we are not alone for our Father is with us. We are pilgrims, our life is a long walk, a journey from earth to heaven.

The beginning of this life is this. There is one who remembereth no more Her sorrow and Her anguish for joy that a man is born into the world. She is our Mother. The end of our pilgrimage is the entering in Our Fathers [sic] house where are many mansions, where He has gone before us to prepare a place for us. The end of this life is what we call death—it is an hour in which words are spoken, things are seen and felt that are kept in the secret chambers of the hearts of those who stand by, it is so that all of us have such things in our hearts or forebodings of such things. There is sorrow in the hour when a man is born into the world,

but also joy—deep and unspeakable—thankfulness so great
that it reacheth the highest Heavens. Yes the Angels of God,
they smile, they hope and they rejoice when a man is born
in the world. There is sorrow in the hour of death—but there
too is joy unspeakable when it is the hour of death of one
who has fought a good fight.

For Reflection

Have you made a pilgrimage to your childhood home or school,
or to some event deep in your own private memories? Does the
word *pilgrim* bring to mind stories of pilgrims over the centuries
who went through great difficulties to visit some site of great
suffering, great healing, or new possibilities? Does the word
strangers add some sense of your life as journey, including times of
rich solitude or loneliness?

For Creative Engagement

Try a pilgrimage in the imagination. Arrange the time
to return to some moment and place in your own life
journey that calls for meditative attention. Perhaps it
is a moment needing healing, or perhaps a moment
that rekindles your enthusiasm for life and offers new
direction for daily tasks. Is there a place you need to
revisit? Is there a pilgrimage place in your art, your
work, your story that will help you deepen your life
journey tomorrow? Visit that place.

ILLUMINATION 3

Understanding the Place of Failure— and of Equal Ground

We know little about the three months Vincent spent in Antwerp at a Belgian training school for evangelists. But this letter in November of 1878 gives a glimpse of his life there and his fervent hope to serve in the Borinage region, with its coal mines and villages of miners.

This letter to Theo brings to light Vincent's dual passions. First, he wants to follow in the spiritual footsteps of his father, the Dutch Reformed pastor, and second, he has a passion for certain artists and their work of revealing and consoling. While he wishes to preach the gospel to the poor, he is also deeply attracted to art and artists who recognize and share the plight of the poor, the marginalized, and the forgotten.

The passages below show something of the struggle between Vincent's two passions at a moment when he is still certain that

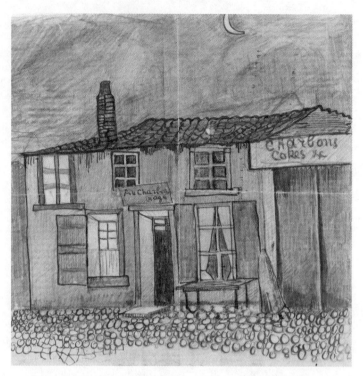

preaching is his "real work," though his other inclinations lead him to sketch his contacts with laborers and, in this case, a café where they eat and drink. The letter also contains one of the most beautiful passages on the consolations of art itself: "How much there is in art that is beautiful, if only one can remember what one has seen, one is never empty or truly lonely, and never alone."

As the letter comes to a close, it reveals that Vincent has not been approved to complete his studies on the traditional basis as the other students in the training school, but it has been decided

that he will take a temporary appointment to the Borinage, allowing the board of evangelists to further review his qualifications. Later letters to Theo reveal that Vincent was ultimately rejected by the board; Vincent describes the blow of that decision and the negative image of "organized religion" it left with him.

While this letter is only one example, throughout Vincent's life and letters, we see the long history of his struggle among diverse views of religion, as well as diverse views within the arts. Both in his words and in the "scratch" drawings, we see witness his desire to understand and sketch the places, people, and landscapes that informed his deepest questions related to religion, the human condition, and the arts.

Vincent to Theo, Letter 148

Laken, November 1878

You see, it always strikes me and it is remarkable, when we see the image of unutterable and indescribable forsakenness—of loneliness—of poverty and misery, the end of things or their extremity—the thought of God comes to mind. At least this is the case with me, and doesn't Pa also say: There is no place I would rather speak than a cemetery, for there we are all on equal ground—there we not only stand on equal ground but there we also *feel* that we are standing on equal ground, and elsewhere we don't always feel that. . . .

I hereby enclose that scratch, 'The Au charbonnage café'. I should really rather like to start making rough

sketches of some of the many things one meets along the way, but considering I wouldn't actually do it very well and it would most likely keep me from my real work, it's better I don't begin. As soon as I got home I began working on a sermon on 'the barren fig tree', Luke XIII:6–9.

For Reflection

Does your past include at least one passionate life plan that failed and brought days of misery and depression? Can you remember the confusion and pain it brought? Vincent's Borinage plan to preach and teach in the small mining villages of Belgium failed and seemed to end in disaster. But without that failure, he may not have become an artist—or seen the suffering of others and in that light understood himself to be on equal ground. Did your apparent failure bring new discoveries about yourself and new opportunities to explore your hidden gifts? Are you still in search of such alternative ways of living?

For Creative Engagement

Revisit your memory of apparent failures. See if there is more to discover about yourself in such events than you have yet found. Let your memory search out clues to gifts you have yet to realize. Is there some creative pathway that appeared to be a failure, yet promises greater depth and meaning in the days ahead?

ILLUMINATION 4

How Art Puts Things into a New Light

One night nearly at midnight, Vincent writes from a Belgian mining village where he has been serving as an evangelist, teaching, preaching, and nursing ill miners and their families. He had found this temporary position after being asked to resign from his position at the Goupil art firm after seven years of service. He had moved to teaching and preaching in England, and then abandoned an attempt to prepare for entry to a Dutch university to study theology. To his family, his failures are a troubling concern, quite the contrast to brother Theo's advancements at Goupil. Vincent has heard from home that Theo is being sent by the famous art firm to their Paris office, and he hopes Theo will stop en route to Paris to visit him. By his next letter, we find that Vincent has been drawing pictures of life among the miners and hopes to show these beginner's artistic efforts to Theo, the art dealer. As Theo's career is on

the rise, it's now clear that Vincent is losing even his temporary position living and working among laborers.

That at such a moment Vincent wants to describe a book he is reading by an American writer likely struck Theo as a frustrating example of his brother's idleness and lack of direction. But for Vincent, his reading and rereading of Harriet Beecher Stowe's *Uncle Tom's Cabin*, alternatively titled *Life among the Lowly*, awakens him to a deep relationship among the arts, religion as compassion, and the call for social engagement.

In Vincent's search for meaning, perhaps this author, who came, as he did, from a family of pastors, revealed a way to bring together the deeper currents of spiritual feeling, purpose in the arts, and a way to serve those in most desperate need. Writing to her editor, Gamaliel Bailey, Stowe shares her

understanding of her role in this novel on slavery: "My vocation is simply that of a painter and my object will be to hold up in the most lifelike and graphic manner possible Slavery, its reverses, changes, and the negro character, which I have had ample opportunity for studying. There is no arguing with pictures and everybody is impressed by them,

whether they mean to be or not." As Vincent studies her novel, he is moved, perhaps even awakened, to the power of both words and images to engage the public and liberate "the lowly." This leads him to consider the very meaning of art and the heart of the vocation of the artist as liberator.

Published a year before Vincent was born, *Uncle Tom's Cabin* had immediately been hailed by many as the "great American novel" and "a masterpiece of social realism." Stowe's work was praised for demonstrating the power of art to move readers to empathy and to engage them in advocating on behalf of those who were marginalized. The novel was lauded by such luminaries as Dickens, George Eliot, and Charlotte Brontë in England, Victor Hugo in France, Leo Tolstoy and Turgenev in Russia, and was "authenticated" by former slave Frederick Douglass in America as "the master book of the nineteenth century." In its first year it sold over 300,000 copies in America and a million in England; soon it was being read around the world. That the book became a part of Vincent's understanding of the liberating role of art is indicated by the fact that he placed a painting of the book, title clearly visible, in one of his portraits of Madame Ginoux, wife of the proprietor of the Night Café, a place that attracted the troubled and homeless of the city of Arles.

Vincent to Theo, Letter 152

Wasmes, June 1879

Am currently reading *Uncle Tom's cabin* [*sic*] a lot—there's still so much slavery in the world—and in that astonishingly beautiful book this extremely momentous matter is treated with such wisdom, with a love and a zeal and interest in the genuine welfare of the poor and oppressed, that one can't help coming back to it again and again and finding more in it each time.

I know no better definition of the word *Art* than this, 'Art is man added to nature', nature, reality, truth, but with a meaning, with an interpretation, with a character that the artist brings out and to which he gives expression, which he sets free, which he unravels, releases, elucidates.

A painting by Mauve or or Maris Israëls speaks more and more clearly than nature itself. So it is with books as well, and in Uncle Tom's cabin in particular, things have been put in a new light by the artist, and thus in that book, even though it's already beginning to be an old book, i.e. one written years ago, all things are made new. It's so subtly felt, it's so well worked out, it's so masterly. It was written with so much love, so much seriousness and so faithful to the truth and with knowledge of the subject. It's so humble and simple but at the same time so truly sublime, so noble and so distinguished.

For Reflection

Do you know the word *bibliotherapy*? Its simple meaning is "healing through a book." Has your own reading or rereading of the right book at the right moment ever healed a wound or inspired you to find new answers or to meet some new challenge? For Vincent, in deep depression, the American novel *Uncle Tom's Cabin* proved to be the right book at the right moment, showing him a way to be faithful to serious truths and to witness the way art might shine a light on that truth, raising up people society has demeaned.

For Creative Engagement

Search out a book that is right for this moment in your life, to heal or inspire, offering to share with you its story and wisdom. Simply wander the shelves of a nearby bookstore or library and read the book titles as you walk. Does one speak directly to you? Has a website or a family friend suggested a likely book to you? Is there a book you have read that seems just right for some friend in need? That might be your own invitation to an act of "bibliotherapy."

On the Love of Books

Concentration and creativity are both essential in a deep reading of Vincent's letters. A year beyond Vincent's letter in praise of Harriet Beecher Stowe's *Uncle Tom's Cabin*, we find him still hidden among the mining villages in Belgium's Borinage region. While many of his letters to Theo from this time are lost, it seems Theo has given up on Vincent's ever finding stable employment that will provide him with a "living." Theo has come to view Vincent's love of reading as hardly serving any practical purpose, while his earlier focus on art and artists at least served the Goupil Company's financial success and provided a salary. After a long silence between the brothers, Vincent feels forced to write Theo upon learning that Theo was providing the money sent through the Van Gogh family to the Borinage, keeping Vincent alive.

This letter (#155), as well as the previous one (#154), is among the longest and most confessional of Vincent's letters, filled with powerful images and examples from his life experience.

He admits to his
many faults, but
defends his reading
and the power of
literature to prepare
us for life, provide
us with wisdom,
and awaken us to
society's needs. In a
sense, Vincent defends his own personal "Great Books" approach
to life, and the patience required for a "humanities" education. In
its own time, he feels, this approach will lead him to his life's work.
It is part of what he calls in this letter his enrollment in the "great
university of poverty." (In Letter 154 he had used wry humor to
explain the Van Gogh family's advice for him, offering him plans for
his improvement, including his becoming a printer of calling cards,
a baker, and a barber. These, he writes, would be false cures, worse
than no cure at all.)

Now in Letter 155 we read that Vincent has sought meaning in
the Greek tragedies, Shakespeare, the Gospels, Harriet Beecher
Stowe, Bunyan, Hugo, and both new and old works of world
literature. The ability of the stories of humanity to awaken and
change one's life is no less than the power of Rembrandt, Delacroix,
Millet. These, too, are the greatest of arts. Perhaps Vincent's
realization that words and images share a power to engage us in the
deepest level of life's meaning and in the most significant service to
humanity is his message in this letter. For Vincent, it's important to
pay attention to and honor each person's inner search.

He goes on to explain his apparent idleness: "Someone has a great fire in his soul and nobody ever comes to warm themselves at it, and passers-by see nothing but a little smoke at the top of the chimney and then go on their way." Can anything help this caged prisoner in his inner struggle to find his vocation? Vincent answers his own question with this appeal to brother Theo: "What makes the prison disappear is every deep, serious attachment. To be friends, to be brothers, to love; that opens the prison."

Vincent to Theo, Letter 155

Cuesmes, June 1880

So it would be a misunderstanding if you were to persist in believing that, for example, I would be less warm now towards Rembrandt or Millet or Delacroix, or whomever or whatever, because it's the opposite. But you see, there are several things that are to be believed and to be loved; there's something of Rembrandt in Shakespeare and something of Correggio or Sarto in Michelet, and something of Delacroix in V. Hugo, and in Beecher Stowe there's something of Ary Scheffer. And in Bunyan there's something of M. Maris or of Millet, a reality more real than reality, so to speak, but you have to know how to read him; then there are extraordinary things in him, and he knows how to say inexpressible things; and then there's something of Rembrandt in the Gospels or of the Gospels in Rembrandt, as you wish, it comes to more or less the same, provided that one understands it rightly, without

trying to twist it in the wrong direction, and if one bears in mind the equivalents of the comparisons, which make no claim to diminish the merits of the original figures.

If now you can forgive a man for going more deeply into paintings, admit also that the love of books is as holy as that of Rembrandt, and I even think that the two complement each other.

For Reflection

If you were to hunt up copies of the books Vincent mentions as important to him, they would fill a large bookcase of many shelves. If it is Vincent's art that attracts us, are there clues to his creativity and his paintings in those very books he valued? Why did he seek to read all of Charles Dickens's novels, all of Zola's works, the poetry of Longfellow and Whitman? Might your reading be a chief resource for your own creativity?

For Creative Engagement

Keep a book that promises to deepen your thinking beside your chair or bed, and begin to note those deepenings as they come. Ask those you admire to tell you what reading means most to them, and listen for different ways to read and understand. Watch for authors who are doing public readings from their works. Might there be a book club nearby for sharing your ideas? Is there a writing group that would encourage you to explore your own stories?

Choosing "Lady Nature"

As mentioned in the introduction, of the 820 letters written by Vincent van Gogh, 658 are written to his brother Theo, and these are the book's focus. But a significant number of the remainder were written to Vincent's artist friends. The largest group of those letters, fifty-eight of them, were written not to the famous Gauguin or the promising young Parisian painter, Émile Bernard, but to a younger Dutch artist whose name has largely dropped out of the history of art: Anthon van Rappard. His will to succeed in the arts is second only to that of Vincent himself, but in Vincent's view, van Rappard lacked one thing: the courage to explore new ways of broadening and deepening his art and, so, his life.

Rappard, in Vincent's view, was a "caterpillar" like Vincent himself, with the promising possibility of transforming into a butterfly. As this urgent letter arrives, Rappard was choosing to

remain tied to the professional
art academies and their tired
themes and burdensome rules,
even as he shared Vincent's
own interest in the poor and
in day laborers, and spent
time in the huts of Dutch
peasants. In Vincent's view,
his friend Rappard lacked the
courage to free himself from
the pharisaic rules of the old
society and its now stifling
art. Rappard, he felt, failed to
choose to improvise, on the
"open seas" of an emerging life
of freedom. Vincent appears
as an evangelist in his letters to Rappard,

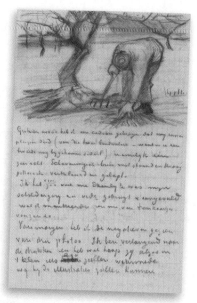

attempting to save him, to convince him that the official academy
is a "cold mistress" that "freezes artists to death." Vincent's
dramatic allegories and carping ways in the letters to Rappard,
while perhaps frustrating to readers, show the zeal with which
he seeks to "save" a rich and talented young man tied to the
safety of his well-off family, his famous teachers, and his society
friends. Vincent sees Rappard as a critical test that a new society
of younger artists might be liberated from the legalistic academy
and devote itself to "Lady Nature or Reality." The larger question
implied by Vincent's letter is: Do we choose old injustices and
entrenched privilege or dare improvising on the open sea of

contemporary reality? The intent of "Lady Nature or Reality" becomes for Vincent a poetic creed for a new life of service. As he identifies "Lady Nature or Reality," he describes her intentions in the passage below and names her acts that promise to lead any attuned to her to one's own way of the heart.

Vincent to Anthon van Rappard, Letter 184
Etten, November 12, 1881

She [Lady Nature or Reality]?—Where she lives, I know well where, and it's not far from each one of us.

She—Her intentions? What do I know of them, how to say it—I'd like to keep silent—however, since we must speak—ah, well—it seems to me: to love and to be [lovable]—to live, to give life, to renew it, to heal it, to preserve it, to work, to give back spark for spark; above all, to be good, to be useful—to be of some use, to light the fire, for example, to give a child a piece of bread and butter, a sick man a glass of water.

Ah, but all that is very beautiful, very sublime. Yes, but she didn't know that it was called that, she believed that it was quite simple, she doesn't do it on purpose, it wasn't her intention to make as much noise as that, she believed nobody paid attention.

Her own 'arguments', you see aren't very brilliant, not very well thought out. Her sentiment is always right.

To know what her duty is she doesn't go to her head, she goes to her heart.

For Reflection

Vincent challenged a young Dutch artist friend who followed the old official rules of the art establishment to dare liberating himself by "improvising" on the "open sea" of "Lady Nature." Vincent suggests that the way to begin is to find the most ordinary tasks one might do to help the lives of those nearest to us. Is that pathway into nature and humanity a way to locate your own freedom and creativity?

For Creative Engagement

Do you tend to seek such far-off and unlikely ways of being creative that you soon give up on the project? Vincent suggests beginning here: "to love and be loveable," to be "useful," to "give a child a piece of bread and butter, a sick man a glass of water." Can you find such ordinary opportunities for a new beginning in creative work? Make a commitment to finding some immediately present opportunity for creative doing. End the day by listing your most ordinary creative engagements in the world around you that helped a life in society or the natural world.

Love What You Love

Vincent refused to give up hope that the young, well-off Dutch artist Anthon van Rappard would finally reject the art academies and their system and join him in pursuit of a new art of freedom and experimentation. His struggle to convince Rappard continued through many letters and several visits by Vincent to his friend's well-stocked studio, as well as through Rappard's visits to the Van Gogh family parsonage in Etten. There, the two artists shared painting excursions in the Dutch countryside, often painting side by side. Experts have sometimes mistakenly attributed an early Rappard painting for a Van Gogh.

In 1889 Rappard married and moved to a farmstead in Santpoort near the city of Haarlem. Weakened by what was commonly referred to at the time as "brain fever," he died in 1892 at the age of thirty-three. But already a decade before the loss of his friend, Vincent was losing two battles at the same time

during the memorable summer and autumn of 1881: his attempt to persuade Rappard to join him in the new art, and his attempt to convince his cousin Kee Vos, a recent widow, to marry him. Despite all his efforts to find fellow workers and companions, Vincent remained alone in his quest, except for the ongoing support of his brother, Theo.

In Letter 188, Vincent continues to urge Rappard to "plunge . . . head over heels . . . into reality." In Rappard's lost responses, he apparently accused Vincent of being "headstrong"

and criticized the clumsiness of Vincent's own artistic efforts. In the passage below from Vincent's letter, he refuses to give up on Rappard as a fellow adventurer on the "open sea." Only one letter from Rappard to Vincent has been preserved, because Vincent returned it to him, filled as it was with harsh criticism for Vincent's first masterwork, *The Potato Eaters*. In his November 1881 letter, Vincent points out to Rappard how strange it is that most people put their effort into what he views as unworthy causes while ignoring what they claim to love.

Vincent to Anthon van Rappard, Letter 188
Etten, November 21, 1881

Now you'll say that I'm actually a headstrong person and that I'm in fact preaching a doctrine.

Well, if you want to take it that way, so be it, I don't necessarily have anything against it. I'm not ashamed of my feelings, I'm not ashamed of being a man, of having principles and faith. But where do I want to drive people, especially myself? To the open sea. And which doctrine do I preach? People, let us surrender our souls to our cause and let us work with our heart and love what we love.

Love what we love, what an unnecessary warning that seems, and yet how great a *raison d'être*. After all, how many people expend their best efforts on something that isn't worthy of their best efforts, and treat what they love in a 'stepmotherly' fashion instead of giving themselves openly to the irresistible urging of their heart.

For Reflection

Often it is the most ordinary observation of Vincent's that catches the reader's attention and embeds itself in the memory. "Love what we love" is such an observation. "After all, how many people expend their best efforts on something that isn't worthy

of their best efforts," says Vincent, suggesting that the things we really love are often taken for granted and starved for our attention. Do you spend your time and energy on lesser things that matter little, while ignoring what you know in your heart you truly love?

For Creative Engagement

Note in a journal how you spend your time over the course of one week. At the end of the week, examine how much time was given to unimportant tasks and worries, and how much time was engaged in what your heart honestly tells you is what you love. Devote the week ahead to attending seriously to what you love, to offering proper attention to what your heart tells you matters most in life.

ILLUMINATION 8

Scrape Everything Off Twice

When Vincent's father ordered him out of the parsonage at Etten at Christmas 1881 for his refusal to attend church services, he left for The Hague, continuing his efforts to become an artist. His uncle, the artist Anton Mauve, guided him in his very first painting there. But Mauve was soon unwilling to help him further when he discovered that Vincent had taken in a sick prostitute and her children. Now on his own and without a mentor, Vincent walked the few miles from The Hague to the North Sea coastal fishing village of Scheveningen to attempt his second painting: a stormy seascape with a fishing boat being brought to shore.

That rather small painting was to have a strange history. It was stored with other early works in the Van Gogh family house in Breda, until it was sold as rubbish to a merchant in 1902, who sold it to a tobacco importer the following year. The merchant's daughter left the painting to the Netherlands on her death in 1989. That work, *Beach of Scheveningen in*

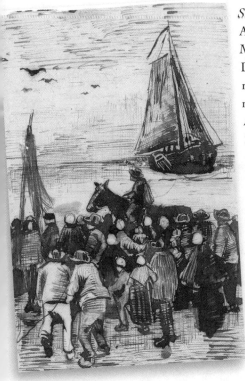

Stormy Weather, placed in Amsterdam's Van Gogh Museum, was stolen on December 7, 2002, and remained missing for more than thirteen years. After its recovery in 2016, it was placed in the museum to be seen again.

But as strange as that story is, it is no more exciting than the day Vincent created the painting in that North Sea storm, as we hear in his letter to Theo. Here we have an unforgettable glimpse into Vincent's determination to complete the task and take one further step toward life as an artist, in spite of all the difficulties that surrounded him. The painting hanging in the museum still contains the grit and sand of the storm on its surface, something that even his scraping down of the painting to begin again didn't remove.

Vincent to Theo, Letter 259

The Hague, August 26, 1882

All this week we've had gales, storms and rain here, and I've been to Scheveningen many times to see it. And came back with two small seascapes. There's already a lot of sand in the one, but with the second, when there really was a storm and the sea came very close to the dunes, I had to scrape everything off twice because of the thick layer of sand completely covering it. The wind was so strong that I could barely stay on my feet and barely see through the clouds of sand. I tried to get it down anyway by immediately painting it again in a small inn behind the dunes, after first scraping it all off, and then going out to take another look from there. So I have a couple of souvenirs after all. But another souvenir is that I've caught a cold again, with the results you know about, which now force me to stay at home for a few days. . . .

The sea was the colour of dirty dishwater. At that spot there was a fishing-boat, the last in the row, and several dark figures. There's something infinite about painting--I can't quite explain—but especially for expressing a mood, it's a joy.

For Reflection

Vincent obviously found joy in the very difficulty of creating a painting in a seaside rainstorm. Is it often the struggle of creating against all odds that helps you to grow? Is it the refusal to give up when life confronts you with almost impossible obstacles that develops your patience and agility?

For Creative Engagement

Tonight, take time to search your memory for the most difficult situations you have met in creative work. Recall each obstacle and your related feelings. Did you discover secrets about your own perseverance and your own limits? Write down a chief lesson the difficulties themselves taught you. Is positive learning possible for you even when you reflect on a project that has failed? Can you find joy in personal efforts that failed?

Well Worth the Trouble of Devoting One's Life to Depicting the Poetry

In the same letter where Vincent describes his second attempt to paint a seascape in the midst of a storm on the North Sea beach at Scheveningen, we catch a glimpse of the wider context of his life, which owes much to Theo's attempts as peacemaker in the family. We see Vincent's gratitude for Theo's support, as well as the artist's fractured view of the parents he admires and loves, even as he understands they will never appreciate his work as an artist.

We read such intimate words as Vincent expresses his thanks to Theo for defending him to their parents in the parsonage from which Vincent himself was expelled. We also hear Vincent unburden his heart to Theo regarding his relationship to his parents, revealing a deep, emotional, and honest assessment of his father and mother. Can a person

love father and mother even knowing they will never understand one's deepest faith in an art that has the power to transform the lives of those in need? Even beyond that question, can Vincent come to understand that his parents will never value his sacrifices for the sake of that consoling and transforming art?

Vincent to Theo, Letter 259

The Hague, August 26, 1882

Now I wanted to tell you that I entirely agree with various things in your letter. Above all, that I absolutely concur that Pa and Ma, with all their pros and cons, are people who are very rare in this day and age—and all the more so as time passes—and perhaps the new is by no means better—and whom one therefore ought to appreciate all the more. For my part I do indeed appreciate them, only I fear that what you have now reassured them about[,] for the time being would come back, especially if they saw me again. They'll never be able to grasp what painting is, never understand that a figure of

a digger—a few furrows of ploughed land—a bit of sand, sea and sky, are serious subjects and so difficult, but so beautiful too that it's well worth the trouble of devoting one's life to depicting the poetry that's in them. . . . They'll be unable to understand that painting isn't done at a stroke, and they'll always fall back on the idea 'that I can't really do it', and that real painters work in a totally different way.

In short, I dare not cherish any illusions and do fear that Pa and Ma will never take any real pleasure in it. This is hardly surprising and it's not their fault—they haven't learned to see as you and I have learned. They look at different things from us, and we don't see the same things with the same eyes; they don't evoke the same thoughts.

To wish that it could be different is permissible, to expect it is in my view unwise.

For Reflection

Vincent lamented that there were those who did not understand the beauty in simple things like diggers, the furrows of earth, and sand, sea, sky. He told Theo that such things were worth devoting his life to depicting their "poetry." Have you, too, devoted your life to things that others do not value, to finding poetry in things where others find nothing worthwhile? Are you able to follow your own vision when others find no value in it?

For Creative Engagement

Make a list of people who share the vision you pursue. Contact one such person and ask if they have similar rejection experiences. Ask how they have dealt with negative responses. Share your feelings and offer your support. Is it time to gather a group with similar devotion and similar challenges?

ILLUMINATION 10

Nature Speaks in a Thousand Voices

Vincent connected his largely self-taught and personal approach to art with his deep feelings for nature. Some have described the artist as a sort of Saint Francis of Assisi, who celebrated birds as artists and collected and sketched their nests as true works of art. Others focus on Vincent's many paintings that feature the sun and relate those to Francis's "Canticle of the Sun" that goes on to celebrate also the moon, wind, water, earth, and all its creatures—and even death—as belonging to the larger universal family and open to our conversations.

Twenty years after Vincent's death, his sister, Elisabeth, wrote a small book of recollections of her older brother in which she described him as a "young naturalist," hiking alone for miles in the countryside, gathering specimens for his nature collection. She described him as avoiding the village and its streets and wrote that "instead he sought his way through hill and dale, each time discovering surprising views and spying

upon rare animals and birds in their natural habitat. . . .With a thousand voices nature spoke to him, and his soul listened."

Another facet of Vincent's understanding of nature is explored in a letter he wrote to Theo (Letter 292) from The Hague in 1882. Here, Vincent seamlessly connected his views of humanity and his views of landscape, tree roots, cabbages. He saw the world as one family of interrelated living things. "In all of nature," he wrote, "in trees for instance, I see expression and a soul, as it were. A row of pollard willows sometimes resembles a procession of orphan men. Young corn can have something ineffably pure and gentle about it that evokes an emotion like that aroused by the expression of a sleeping child, for example. The grass trodden down at the side of a road looks tired and dusty like the inhabitants of a poor quarter."

One could easily fill a small volume with the passages in Vincent's letters that celebrate one aspect or another of nature. He provides ecstatic descriptions of scenes in the countryside, in farmyards, or by the sea. Vincent often focused on "undergrowth," a patch of grass in the sun, a butterfly on a branch, the wind in a wheat field, sun in a puddle of water. When he wrote the young

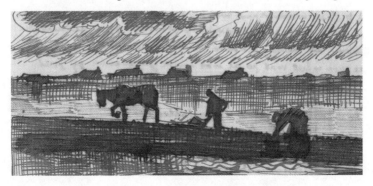

French artist Émile Bernard, he said, "I do what I do with an abandonment to reality, without thinking about this or that" (Letter 698). Writing again to Bernard some years later, he showed his investment in paying attention and in the smaller things: "My ambition is truly limited to a few clods of earth, some sprouting wheat. An olive grove. A cypress" (Letter 822).

After suffering a series of epileptic-like seizures, voluntarily confined in the asylum in Saint-Rémy, Vincent wrote to Theo, "Ah, while I was ill, damp, melting snow was falling, I got up in the night to look at the landscape—never, never has nature appeared so touching and so sensitive to me" (Letter 833). To his youngest sister, Willemien, he wrote, "Have you ever read King Lear? But anyway, I think I shan't urge you too much to read such dramatic books when I myself, returning from this reading, am always obliged to go and gaze at a blade of grass, a pine-tree branch, an ear of wheat, to calm myself. So if you want to do as artists do, gaze upon the white and red poppies with the bluish leaves, with those buds raising themselves up on stems with gracious curves" (Letter 785).

In the passage below, Vincent takes us into the heart of the mystery of the moment when he attempts to paint nature, even if his painting is only the echo of what he hears. Many of us find in Vincent's mystical sense of connection to earth the same puzzling attraction we feel in the presence of his paintings. We discover an invitation to a deep experience of our relationship and conversation with earth and sun, the branch of a fir tree, a few clods of earth.

Vincent to Theo, Letter 260

The Hague, September 3, 1882

I'm glad that I've never *learned* how to paint. Probably then I would have LEARNED to ignore effects like this. Now I say, no, that's exactly what I want—if it's not possible then it's not possible—I want to try it even though I don't know how it's supposed to be done. *I don't know myself* how I paint. I sit with a white board before the spot that strikes me—I look at what's before my eyes—I say to myself, this white board must become something—I come back, dissatisfied—I put it aside, and after I've rested a little, feeling a kind of fear, I take a look at it—then I'm still dissatisfied—because I have that marvellous nature too much in mind for me to be satisfied— but still, I see in my work an echo of what struck me, I see that nature has told me something, has spoken to me and that I've written it down in shorthand. In my shorthand there may be words that are indecipherable—errors or gaps—yet something remains of what the wood or the beach or the figure said—and it isn't a tame or conventional language which doesn't stem from nature itself but from a studied manner or a system.

For Reflection

Have you found insights in the movement to rediscover a home in the beauty and diversity of nature? Do you share the sense of peril in signs of the poisoning of earth, air, and water? What role has the beauty of trees, fields of wheat, a sunset over the sea, or your own garden flowers played in your life and well-being? Does the very act of planting a tree or a flower bring you joy?

For Creative Engagement

View a book of Vincent's paintings and note how many deal with scenes in nature. Spend time with a painting of a single blossoming tree, a butterfly, peasants working in a field, a meadow, a garden. Does the painting communicate his sense of earth's "poetry" to you? Does it cleanse, stimulate, give you a fuller feeling for our place on earth as home? Find a personal pathway into nature, whether in a nearby park or forest or in your own garden. Plant something native to your environment, and watch it grow and change with the seasons. Let nature speak to you.

ILLUMINATION 11

Finding a Place to Go to Work Things Out

Vincent had gone to The Hague to learn and focus on his art—and hopefully, through his painting, to earn enough to pay his way. Though he had learned much, he had failed to earn enough money to care for himself and the woman from the streets and her two children whom he had taken in. By this time, he had also lost the confidence of his parents, and Theo was threatening to withdraw his support. So Vincent sought

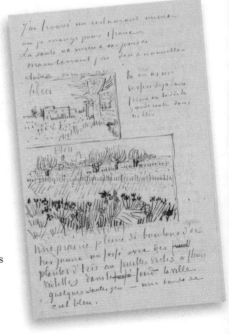

retreat from the world in the northeastern Dutch province of Drenthe. Perhaps in that farthest region from his parents' parish he could make a new start.

Vincent considered settling in Drenthe for a lifetime, painting the peat gatherers, peasants in their dark thatched cottages, and shepherds with their flocks. He described a day of wandering in the peat bogs, heather, and wheat fields as a "symphony," an example of his most positive hopes. But as the loneliness of winter set in, Vincent's sense of loss and loneliness began to reflect back a landscape burdened by cold rains and soon became a challenge.

Even here, though (as he was wont to do in other places), Vincent did discover places of comfort that, at least in part, helped him "work something out." Following is a revealing scene or two from those days in Drenthe.

Vincent to Theo, Letter 390

Hoogeveen, September 26, 1883

Because I have a need to speak frankly, I can't hide from you that I'm overcome by a feeling of great anxiety, dejection, a *je ne sais quoi* of discouragement and even despair, too much to express. And that if I can find no consolation for it, it might all too easily overwhelm me unbearably.

It really bothers me that I have so little success with people in general, I'm very concerned about this, and all the more so because rising above it and getting on with the

work is at stake here. The fate of the woman, moreover, the fate of my sweet, poor little lad and the other child, cut me to the quick. I'd still like to help and I can't. . . .

We're having gloomy, rainy days here, and when I come into the corner of the attic where I've installed myself it's all remarkably melancholy there—with the light from one single glass roof tile that falls on an empty painting box, on a bundle of brushes with few decent bristles remaining, well it's so curiously melancholy that luckily it also has a funny enough side not to weep over it but to regard it more cheerfully.

Just over two weeks later (Letter 395), Vincent describes for Theo his strategy when depression grows too deep to think. There is a special place he can go to find solace. In fact, the following is one of three times in the Drenthe letters that he describes that consoling space:

Well, downstairs is an inn and a peasant kitchen with an open peat fire, very cosy in the evenings. One can think best by one of those peasant hearths with a cradle beside it. If I feel melancholy or can't work something out, I just go downstairs.

For Reflection

Is there a creative space you go when you need to gain perspective on life, some sort of hilltop that allows you a broader and more expansive view? Vincent, who never owned any property other than his clothing and painting kit, searched for such corners in the homes of laborers who took him in, in the small cafés where he could speak with friends, in the wheat fields he painted, or at a peasant's hearth beside a child's cradle with a window on nature.

For Creative Engagement

Search your memory for the corners that have healed and liberated you on your journey. What is it about those spaces that renewed you and inspired you to continue your search for meaning? What does this tell you about yourself and your sources of renewal? Where does it lead you now when depression threatens or weariness darkens your vision? Find such a space that might be nearer than you remembered. Is it a space you carry in your own imagination? If so, visit that space in your heart, resting in the renewal you have experienced before and know you might do again.

Discovering Nothing but the Infinite Earth

Despite the sense of melancholy that came with the landscape of Drenthe, there were also profound insights and an appreciation for the stark terrain. With his hopes having been dashed in The Hague, Vincent went from a desire to see great progress in his art and to develop financial self-sufficiency to once more being mired in debt. In the desolate far northeast of the Netherlands, he sought inspiration among the peasants.

Loneliness often informed Vincent's creative life. A lonely trip exploring the heath and peat bogs of Drenthe resulted in one of the most poetic descriptions of nature in his letters. The trip began when he accepted a ride in a farm wagon in the dark autumn dawn, and continued in the hours after as he walked through the bleak but fascinating peasant landscape.

Vincent to Theo, Letter 402

Nieuw-Amsterdam, November 2, 1883

When it was only just starting to get a little lighter and the cocks were crowing everywhere by the huts scattered over the heath, the few cottages we passed—surrounded by slender poplars whose yellow leaves one could hear falling—an old squat tower in a little churchyard with earth bank and beech hedge, the flat landscapes of heath or wheatfields, everything, everything became just exactly like the most beautiful Corots. A silence, a mystery, a peace as only he has painted. . . .

The ride into the village was really so beautiful. Hugh mossy roofs on houses, barns, sheepfolds, sheds. The dwellings here are very wide, among oak trees of a superb bronze. Tones of golden green in the moss, of reddish or bluish or yellowish dark lilac greys in the soil, tones of inexpressible purity in the green of the little wheatfields. . . .

When one travels for hours and hours through the region, one feels as if there's actually nothing but that infinite earth, that mould of wheat or heather, that infinite sky. Horses, people seem as small as fleas then. One feels nothing any more, however big it may be in itself, one only knows that there is land and sky. . . .

That return of the flock in the dusk was the finale of the symphony that I heard yesterday. That day passed like a dream. I had been so immersed in that heart-rending music all day that I had literally forgotten even to eat and drink—I took a slice of coarse peasant bread and a cup of coffee

ul the little inn where I drew the spinning wheel. The day was over, or rather from one night to the other night, I had forgotten myself in that symphony.

For Reflection

Are there times when the poetry and "music" of a day seems to break through for you in special ways and in special places? Vincent had such a day in the bleak province of the Netherlands called Drenthe. He describes the entire day as a "symphony" bringing to him "a silence, a mystery, a peace." Can you return to such days in your own memory? Might this very day you are now living reveal itself as the "infinite earth" immersing you in its sounds and sights?

For Creative Engagement

Determine tomorrow to seek a deeper vision of this day of your life. Is there a deeper vision of its scenes and duties that can place it for you under an infinite sky, within the infinite life of earth? Rise early enough to see the darkness of night become dawn. Watch the stars disappear in sunrise. Follow the day until darkness returns and the stars appear again. For many, a starry night, the expanse of the sea, or the unfurling of a flower in the garden can offer that sense of the infinite. Where is it most available to you? Listen for that "symphony" that came to Vincent in the midst of discouragement and loneliness.

Searching for the Definitive Pattern

Following his experience of failure among the mining villages of Brussels, at Goupil, and in The Hague, and then his escape from the desolate landscape of Drenthe, Vincent was driven by poverty and loneliness back to his parents' parsonage, now in the village of Nuenen. There, with Theo's support, he sought to become a painter of peasant life. Hiking the Dutch countryside, he did hundreds of drawings and painted sketches of the peasants, their thatched cottages, weavers at their looms, and potato farmers.

After two years of sketching and painting at Nuenen, and soon after his father's sudden death, Vincent attempted what he believed was his masterpiece, a work he felt would qualify him in the eyes of others as a master artist. After making hundreds of preparatory sketches of a peasant family, the De Groots, in their cottage, Vincent began his painting. He painted them gathered around a plate of potatoes, eating their evening meal

[handwritten letter facsimile]

by the light of a lamp after a day of labor in the fields. He called the final versions of this work, including a lithograph, "Five Persons at a Meal."

The work received criticism for its crudeness, but he defended its "truth" and "life." For him, it was a serious work that placed him in the world of fine artists. And it served as his attempt to become a peasant painter in the footsteps of his artist hero, the French painter Jean-François Millet. *The Potato Eaters* was to be both a celebration of honest labor on this earth and a revelation and appreciation of "a different way of life" little known to city dwellers. It was a recognition of the beauty and humanity of those who dig the earth, plant and harvest, and, finally, are buried in that same soil.

Almost two years after the making of the painting, in the autumn of 1887, Vincent would write from Paris to his youngest sister, Willemien, asking her for news about the De Groot family, and he would remember that painting: "What I think about my own work is that the painting of the peasants eating potatoes that I did in Nuenen is after all the best thing I did" (Letter 574). For Vincent, the work of honoring his own vision, discerning the pattern, and doing the preparatory sketches allowed him to

understand and incorporate his own working principles into the building of a masterwork. Whether or not others understand the masterwork, Vincent van Gogh sensed a calling to follow the vision.

Vincent to Theo, Letter 497

Nuenen, April 30, 1885

You see, I really have wanted to make it so that people get the idea that these folk, who are eating their potatoes by the light of their little lamp, have tilled the earth themselves with these hands that they are putting in the dish, and so it speaks of MANUAL LABOUR and—that they have thus honestly *earned* their food. I wanted it to give the idea of a wholly different way of life from ours—civilized people. So I certainly don't want everyone just to admire it or approve of it without knowing why.

I've had the threads of this fabric in my hands the whole winter long, and searched for the definitive pattern—and if it's now a fabric that has a rough and coarse look, nevertheless the threads were chosen with care and in accordance with certain rules. And it might well prove to be a REAL PEASANT PAINTING. *I know that it is. . . .*

And likewise, one would be wrong, to my mind, to give a peasant painting a certain conventional smoothness. If a peasant painting smells of bacon, smoke, potato steam— fine—that's not unhealthy—if a stable smells of manure— very well, that's what a stable's for—if the field has an odour of ripe wheat or potatoes or—of guano and manure—

that's really healthy—particularly for city folk. *They get something useful* out of paintings like this. But a peasant painting mustn't become perfumed.

For Reflection

There are critical moments in life when we seek and, hopefully, find some pattern that gives meaning to our journey. As an artist, Vincent needed a definitive painting that might tell him—if not the world of his day—that he had developed the eyes and touch of a creative artist. For Vincent, that painting was built upon many months of observing the De Groot family of Nuenen as they planted and harvested their potato crop in the same earth where they buried their dead. He felt that moment had arrived when he saw them gather for their evening meal of steamed potatoes. Aren't we all in search of some such token of our life's affirmation?

For Creative Engagement

Search your memory and imagination for a moment that revealed the creative pattern of your living. Is such a moment yet hidden in your daily activities and explorations? Is it hidden in some silent time, some relationship, some gift given or received? Seek to describe such a life event and study its pattern. Does it reveal the direction and promise your future holds? Study and sketch it as Vincent did that family at their shared meal.

The Importance of a Note of Lemon Yellow

Pastor Van Gogh died of a stroke as he returned from parish visits in the village of Nuenen on the evening of March 26, 1885. At that very time, Vincent had been doing studies in the peasant huts of Nuenen, sketches that would inform his masterpiece now called *The Potato Eaters*.

In a letter on April 4, Vincent wrote to Theo concerning the loss of their father, "They have therefore been days that none of us will forget, and yet the overall impression isn't terrible, but only grave. Life isn't long for anyone, and the question is just — to do something with it" (Letter 489).

About six months later, Vincent wrote Theo again, that he had a painting for him, a rather traditional *memento mori* painting with its snuffed-out candle and their father's imposing leather-bound Bible opened to the viewer. Vincent's description of the painting, by its very brevity, often has Van Gogh scholars missing one of the artist's most significant illuminations of his

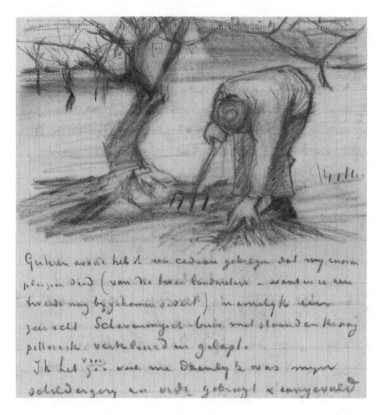

view of religion, the Bible, and the relation of the Bible to artists and the arts. Vincent writes:

"I'm sending you a still life of an open, hence an off-white Bible, bound in leather, against a black background with a yellow-brown foreground, with an additional note of lemon yellow. I painted this in *one go*, in a single day."

That "additional note of lemon yellow" is a rendering of a cheap yellow paperback with the visible title *La joie de vivre* ("The Joy of Living") and the name of its author, Zola. In adding in that paperback, Vincent pushed up against the imposing Bible of his father one of the recent works of modern French literature he and his father often argued about. The flimsy paperback, published just the previous year, is painted on the canvas as already dog-eared and worn from intensive reading. Years earlier, Vincent had complained that when his father saw him with a French book in his hands, he thought "of arsonists and murderers and 'immorality.'" Vincent wrote: "I've already said so often to Pa: just read a book like this, even if only a couple of pages, and you'll be moved by it. *But Pa stubbornly refuses to do so*" (Letter 186).

In contrast to the heavy, leather-bound Bible, Vincent paints the paperback, in effect offering his father, post-mortem, the opportunity to read a specific Zola novel. But in a further move, Vincent shares the parallels. In the painting, the Bible is opened to the book of the prophet Isaiah, chapter 53, a famous piece of prophetic poetry called the "Suffering Servant Songs." Those who know Zola's *La joie de vivre* will realize the parallel: Zola has repeated the "Suffering Servant" plot of Isaiah by telling the story of a mistreated orphan girl named Pauline Quenu, who, cheated of her inheritance, yet heals those around her through a divine patience and compassion.

In Van Gogh's barely hidden message in the details of the painting, we discover an artist challenging the seeming contrast of the two books, while the heavy leather Bible and the flimsy paperback offer the same message of consolation Van Gogh so often emphasized.

In many ways Vincent's work suggests art and artists as the prophets of a new age, offering humanity a new opportunity to understand great literature and, by extension, all the arts as a gospel, as "good news," and as a prophetic voice for suffering humanity.

So Vincent's letter leaves us with much of what he intends unsaid. He invites the careful viewer of his painting to discern the deep meaning of Zola's creative story of suffering and consolation with its mysterious presence in that "additional note of lemon yellow" resting at the foot of the Bible text. The painting itself solves the painting's riddle, each text mirroring the other— and each an invitation.

Vincent to Theo, Letter 537

Nuenen, October 28, 1885

Zola *creates*, but doesn't hold a *mirror* up to things, creates them *amazingly*, but *creates*, *poetizes*. That's why it's so good. . . .

The greatest, most powerful imaginations have also made things directly from reality that leave one dumbfounded. . . . I'm sending you a still life of an open, hence an off-white Bible, bound in leather, against a black background with a yellow-brown foreground, with an additional note of lemon yellow.

For Reflection

The deepest treasures of life may be hidden in something like Vincent's simple "note of lemon yellow" placed beside his father's ponderous Bible. We challenge both ourselves and others to locate our hidden treasure and decode its meaning. The very search for clues to such a treasure may be essential to its meaning. Are you prepared for such a search?

For Creative Engagement

Is there some treasure that remains hidden in you? Will it require patience and wisdom to discover the map that leads to uncovering that treasure? Are there guides you have encountered that can help you find your way to what is deepest in you? And what of the hidden treasures in others that wait for your willingness to search out the best that is in them? Perhaps your willingness to search for the treasures in others is the first clue to your finding your own hidden purpose.

Carry Your Own Quest for Serenity

Willemien was the youngest of the three daughters of Pastor Van Gogh and his wife, Anna. She was born nine years after brother Vincent and died fifty years after his death. It was her fate to remain unmarried and be caretaker to her mother when her husband died in 1885. We have twenty-three revealing letters to her from Vincent, from 1887 to June of 1890, the month before his death. Her desire to be a writer, her reading of both Russian and French literature, and her caregiving work impressed Vincent. His letters to her have a special quality of directness, depth, and humor unique in his correspondence.

In December of 1902, twelve years after Vincent's death, she was admitted as a patient to a psychiatric institution in Holland, diagnosed with dementia praecox ("premature dementia," possibly schizophrenia), and remained there, largely in silence, until her death.

This first letter to Willemien in the Van Gogh collection responds to a lost letter she wrote making an optimistic

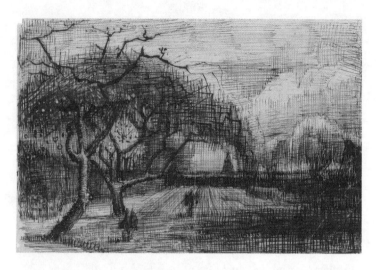

comparison of human life with the life of plants. Vincent points out the problem of her letter's optimism, but adds his own optimistic observation that "what the power to germinate is in wheat, so love is in us." He then suggests she read books that both help us through humor, such as Rabelais and Voltaire, and books that show us "life as it is," recommending works by Zola, Flaubert, and others. Vincent then brings up the question of finding light through reading the Bible, and how this relates to "modern" literature, revealing a deep admiration for the Bible, yet calling his sister (and us as we read over her shoulder, as it were) to discover comparable action necessary in their own time and circumstances. Vincent's letter concludes with a warning that the arts are not everything, and that the need remains for enjoying life itself. Carry your own quest for serenity, he advises Willemien, despite a lack of easy answers to life's most important questions.

Vincent to Willemien, Letter 574

Paris, October 1887

Is the Bible enough for us? Nowadays I believe Jesus himself would again say to those who just sit melancholy, *it is not here, it is risen. Why seek ye the living among the dead?*

If the spoken or written word is to remain the light of the world, it's our right and our duty to acknowledge that we live in an age in which it's written in such a way, spoken in such a way that in order to find something as great and as good and as original, and just as capable of overturning the whole old society as in the past, we can safely compare it with the old upheaval by the Christians.

For my part, I'm always glad that I've read the Bible better than many people nowadays, just because it gives me a certain peace that there have been such lofty ideas in the past. But precisely because I think the old is good, I find the new all the more so. All the more so because we can take action ourselves in our own age, and both the past and the future affect us only indirectly.

For Reflection

Reading in order the entire collection of the twenty-two letters Vincent wrote to his youngest sister may reveal his feelings, humor, and wisdom in a very special way. He loved Willemien's creative spirit, her sacrifices to serve their widowed mother,

and her interests in literature and writing. Perhaps we best understand Vincent in his encouragement of Willemien's own exploration of life. Try reading those letters, and see for yourself.

For Creative Engagement

Do we reveal the best in us when we seek to help others find the best in themselves? Vincent puts aside even his own passion for the arts to encourage Willemien to carry on her own quest for meaning, for joy in life, and for serenity in times of difficulty. When did you most recently put aside your own quest to encourage the quest of another? Is there someone near you who needs your encouragement and support for their own journey? Can you offer such support today?

ILLUMINATION 16

Making What You Can't Yet—Until You Can

Vincent had left Theo's apartment in Paris to arrive in Arles, the old Roman capital of Provence, on February 20, 1888. In spite of all he had learned in the city from the Impressionists regarding color and new ways of seeing, and from the Japanese art he and Theo had begun collecting, he was suffering from the cold weather, had been drinking heavily, and was tired of the arguments among Parisian artists. Further, he was attracted by stories praising the beauty of the south and the power of the Mediterranean sun. Though there was snow on the ground when he arrived in Arles, the countryside was soon blossoming. Amid orchards, fields, and Mediterranean fishing boats, he was in ecstasy painting. By May 1, he had already rented the "Yellow House"—as it has come to be called, based on the title of a painting of it that he made—and hoped to furnish it as his home and studio. This letter of May 26 tells Theo of his explorations of Montmajour, just outside the city. He was

fascinated by the rocky crag, its ruined monastery, and especially its view of farms and fields. He would send several sketches of the site to Theo.

But Vincent was also worried about his brother's health. Dr. Gruby in Paris had diagnosed Theo with a heart problem, and he was only thirty-one years old. Despite—or because of—the seriousness of the matter, in this letter to Theo we have a chance to read Vincent in an imaginative and humorous mode as he attempts to cheer Theo up. Vincent's use of humor mixed with creative imagination has often been overlooked or misunderstood. But certainly it gives us a revealing image of his thinking about religion, art, and other matters.

Vincent's imaginative approaches to religious questions are also found in his letters to the young artist Émile Bernard. In one from June 1888, for instance, he describes life as a sphere made of two hemispheres, the unknown second hemisphere likely "far superior in extent and potentialities to the single hemisphere that's known to us at present" (Letter 632).

Soon after, in a letter to Theo on July 10, Vincent returns to the topic of his brother's health, even

extending his imaginative thoughts to the matter of death. He writes, "For myself, I declare I don't know anything about it. But the sight of the stars always makes me dream *in as simple a way* as the black spots on the map, representing towns and villages, make me dream. Why, I say to myself, should the spots of light in the firmament be less accessible to us than the black spots on the map of France. Just as we take the train to go to Tarascon or Rouen, we take death to go to a star" (Letter 638).

Vincent to Theo, Letter 613

Arles, May 26, 1888

I'm thinking more and more that we shouldn't judge the Good Lord by this world, because it's one of his studies that turned out badly. But what of it, in failed studies—when you're really fond of the artist—you don't find much to criticize—you keep quiet. But we're within our rights to ask for something better. We'd have to see other works by the same hand though. This world was clearly cobbled together in haste, in one of those bad moments when its author no longer knew what he was doing, and didn't have his wits about him. What legend tells us about the Good Lord is that he went to enormous trouble over this study of his for a world. I'm inclined to believe that the legend tells the truth, but then the study is worked to death in several ways. It's only the great masters who make such mistakes; that's perhaps the best consolation, as we're then within our rights to hope to see revenge taken by the same hand.

And—then—this life—criticized so much and for such good, even excellent reasons—we—shouldn't take it for anything other than it is, and we'll be left with the hope of seeing better than that in another life.

For Reflection

To the artist Rappard, who had criticized *The Potato Eaters*, Vincent once wrote, "I keep on making *what I can't do yet* in order to learn to be able to do it" (Letter 528). Vincent certainly knows his own art has failures, but believes we must try to do more than we currently know how to do if we are to do better work in the future. In a similar vein, to cheer brother Theo, Vincent admits that God made mistakes in creation, but will improve with practice.

For Creative Engagement

Have you dared to attempt more than you can currently do successfully? Today, give it a try. Are you willing to accept your own failures as a way to deeper and broader creative work? Take a chance on yourself in this way. Do you have a sense of humor that allows failures to become rungs on a ladder toward future discoveries and successes? Look for ways to laugh at your failures this day.

ILLUMINATION 17

Discovering a Philosophy of the Seasons and a Selfless Emptiness

Vincent's contact with Japanese art would have a profound effect on him and on his relationship to nature and the seasons, ordinary scenes of daily life, and his use of color. After the death of his father, and completing his masterwork, *The Potato Eaters*, Vincent had left Nuenen for Antwerp, Belgium, intent on continuing his artwork. There, an early letter to Theo records a new theme emerging as Vincent describes decorating his rented room with "a set of Japanese prints on the walls that I find very diverting. You know, those little female figures in gardens, or on the shore, horsemen, flowers, gnarled thorn branches" (Letter 545). Vincent's eye perceived the Japanese love of nature, and

perhaps even something of the philosophy of the seasons and of a selfless emptiness that resides in Japanese Zen Buddhism.

In the very year of Vincent's birth (1853), Admiral Matthew Perry had sailed his gunboats into a Japanese port and forced Japan to open to trade with the West. Suddenly, cities like Antwerp and Paris were flooded with Japanese art and diverse Oriental influences. After Antwerp, Vincent would move into Theo's apartment in Paris, discovering a large selection of Japanese prints in the nearby shop of an importer and art dealer named Bing. The Van Gogh brothers began to collect and exhibit Japanese prints, and Vincent painted copies of some of the works. The influence would be long-standing. Years later, Vincent shared a self-portrait with Gauguin—a painting of himself as a Japanese monk. This painting now hangs in Harvard's Fogg Art Museum.

The passages from Vincent's letters below add another facet to our understanding of the artist and beg the question, In Vincent's exploration of Japanese Buddhist influences and art, alongside his Dutch spiritual roots and personal affinity for Western peasants and their landscapes, was he one of the first to thoughtfully and meditatively cojoin an Eastern and a Western perspective? Did his focus on the first thing one sees find support in the Japanese artist's study of "a single blade of grass" (Letter 686)? Perhaps Vincent's search

for a broader understanding of spirituality and the infinite was now being nourished by an Eastern art and spirituality that would in turn nourish many other seekers down to the present day. For those who seek to engage their local environments and to learn from other artistic and religious traditions, Vincent's bold explorations illumine the path.

Vincent to Theo, Letter 620

Arles, June 5, 1888

About staying in the south, even if it's more expensive—Look, we love Japanese painting, we've experienced its influence—all the Impressionists have that in common—and we wouldn't go to Japan, in other words, to what is the equivalent of Japan, the south? So I believe that the future of the new art still lies in the south after all.

Vincent to Theo, Letter 686

Arles, September 24, 1888

If we study Japanese art, then we see a man, undoubtedly wise and a philosopher and intelligent, who spends his time—on what?—studying the distance from the earth to the moon?—no; studying Bismarck's politics?—no, he studies a single blade of grass.

But this blade of grass leads him to draw all the plants—then the seasons, the broad features of landscapes, finally

animals, and then the human figure. He spends his life like
that, and life is too short to do everything.

Just think of that; isn't it almost a new religion that these
Japanese teach us, who are so simple and live in nature as
if they themselves were flowers?

For Reflection

Upon leaving Paris for Arles in Provence, Vincent discovered
a land like that found in the Japanese prints he and Theo had
begun to collect. The creators of those prints seemed to respond
to the simplest scenes in nature, following the colors and forms of
the seasons. Can one empty the ego to live more like those who
follow nature in its changes? Can a "Westerner" develop an eye
more "Japanese?"

For Creative Engagement

Does your own vision of life on earth cross borders and
seek inspiration from other peoples and lands? Do you
find your very way of seeing deepened and broadened
by viewing the lives and arts that see nature differently?
Concentrate on one image valued for its Eastern vision,
in a book or a museum. Can you begin to see a season, a
tree, a seascape, "a single blade of grass" with fresh eyes
taught by another culture's discoveries?

Finding the Work

Of the 820 letters in our possession written by Vincent, the twenty-two letters written to his youngest sister, Willemien, give us some of the most candid images of Vincent as he freely shares with her his views of himself, life and death, and the joys and sorrows of his work as an artist. Reading those letters, it's obvious that his love for Willemien allows him a special freedom and spontaneity in writing. He writes as an older brother, explaining to her who the Impressionists are, why artists paint, and what he has and hasn't achieved in life at age thirty-five.

For Vincent to take the opportunity to write about his work and that of the Impressionists, and also to take a step back to see what he has—or hasn't—achieved, gives Willemien a most intimate portrait of her brother's life. These letters also serve to

inspire us whose creative imagination wants to articulate what the goal is, what the work means, who our artistic peers are, and what we've discovered about life.

Vincent to Willemien, Letter 626

Arles, June 1888

Many thanks for your letter, which I'd been looking forward to; I daren't give way to my desire to write to you often or to encourage this on your part. All this correspondence doesn't always help to keep us, who are of a nervous disposition, strong in cases of possible immersions in melancholy of the kind you refer to in your letter and which I myself have too every now and then. . . .

Something else: someone who can really play the violin or piano is, it seems to me, a mightily entertaining person. He picks up his violin and starts to play, and a whole gathering enjoys it all evening long. A painter has to be able to do that too.

And this sometimes gives me pleasure, to work outside when someone's looking on. One is in the wheat, say. Well then, in the space of a few hours one has to be able to paint that wheatfield and the sky above it and the prospect in the distance. Anyone who watches that will certainly keep his mouth shut afterwards about the clumsiness of the Impressionists and their bad painting, you see. But nowadays we seldom have acquaintances who are interested enough to come along now and again. But when they do, then they're sometimes won over for good. . . .

You see what I've found, my work, and you also see what I haven't found, everything else that's part of life. And the future? Either become wholly abstracted from what isn't the work or . . . I dare not elaborate on that 'or' because becoming nothing but a work machine, unfit for and indifferent to all the

rest, could be either better or worse than that average. I could quite easily resign myself to that average, and for the time being the fact is I'm still in the same junk heap as ever. . . .

If you were within my reach you would, I fear, have to get down to painting.

For Reflection

Vincent shared with youngest sister Willemien his worries, his failings, and his fondest hopes. He believed they both suffered from "a nervous disposition" and "possible immersions in melancholy." He shared with her his joy in painting, performing a work in a wheat field "when someone's looking on." He could write that he had found his work, but admitted that might make him too distracted to fit easily into the rest of life. Is finding one's work not only an accomplishment but also a challenge, with a price to be paid?

For Creative Engagement

Have you struggled to find your work, your art, your place in life? Think about your creative possibilities, both the joy they bring and the price you must pay to pursue them seriously. Can your work also feed your art of daily living? Is it possible to balance creative practice and a meaningful life with others? Searching for answers to such difficult questions may best be done with others who are on the same search. Try opening this conversation with people you know who are struggling for similar answers.

The Art of Making Life

Vincent van Gogh's early letters show clearly the great influence of parsonage life that led him to love the Bible, prayers, hymns, and a Dutch spirituality of the self-giving love of the biblical Christ. He copied Thomas à Kempis's *Imitation of Christ* word for word, and many of his early letters to Theo offer page after page of biblical quotations, Christian hymns, and prayers memorized from his time in the parsonage. But one must follow Vincent's spiritual path with care, for it grows, questions, experiments, and transforms throughout his brief lifetime.

There's often an "elephant in the room" when it comes to interpreting Vincent's spirituality and interest in the Bible through the letters. Most of his letters are to Theo, who, once he began work as a businessman in Paris, lost all interest in the Bible or formal religion. When Theo married, even at the cost of offending his religious mother he insisted his wedding not be a religious ceremony. It may be that Vincent felt he needed to avoid religious subjects with Theo unless Theo raised the topic. Theo apparently did not.

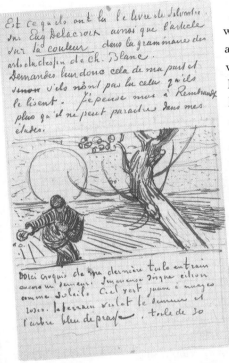

The one person who wished to discuss religion and Bible with Vincent was the young artist Émile Bernard, and their letters become the chief source of information about Vincent's transforming faith. These letters make clear that, for Vincent, Jesus was the greatest of artists and that Jesus's peasant-centered themes of sowing and harvesting, as well as Jesus's compassion for the poor and disinherited, inspired Vincent's personal spirituality and art.

For creatives looking at Vincent's understanding of his artwork, it is important to note that he viewed it as situated within a larger religious or philosophical construct. This affected his personal values and even his subject matter—where his focus on the disenfranchised and his understanding of "working in living flesh" were part of building out his dynamic body of work.

Vincent to Émile Bernard, Letter 632

Arles, June 26, 1888

You do very well to read the Bible—I start there because I've always refrained from recommending it to you. . . .

The Bible—that's Christ, because the OldTestament leads towards that summit; St Paul and the evangelists occupy the other slope of the holy mountain. . . .

Christ—alone—among all the philosophers, magicians, &c. declared eternal life—the endlessness of time, the non-existence of death—to be the principal certainty. The necessity and the *raison d'être* of serenity and devotion.

Lived serenely as *an artist greater than all artists— disdaining marble and clay and paint—working in* LIVING FLESH. . . .

Christ—although he disdained writing books on ideas and feelings—was certainly much less disdainful of the spoken word—THE PARABLE above all. (What a sower, what a harvest, what a fig tree, &c.) . . .

These reflections, my dear old Bernard—take us a very long way—a very long way—*raising us above art itself*. They enable us to glimpse—the art of making life, the art of being immortal—alive.

Do they have connections with painting? The patron of painters—St Luke—physician, painter, evangelist—having for his symbol—alas—nothing but the ox—is there to give us hope.

For Reflection

Vincent brought together his early parsonage religious education and his painting by viewing Jesus as the peasant-centered artist of spoken parables: "what a sower, what a harvest, what a fig tree." Jesus's art was worked "in living flesh," Vincent wrote, and so the art of life went beyond even that of painting. Can we find a similar way of bringing all our creative work together as an art of living, of sowing and harvesting new life on planet Earth?

For Creative Engagement

Do your creative acts come together in the "art of making life"? The therapist who survived the Holocaust, Viktor Frankl, in his book *Man's Search for Meaning*, suggested that we now imagine ourselves on our deathbed looking back on what was most meaningful in life. Choose those very things as the pattern for living your life now.

A Devotion to What Is Nearest

On February 28, 1886, Vincent van Gogh surprised his brother Theo by suddenly arriving in Paris, where Theo was manager of the gallery of a new generation of Goupil and Company, Boussod and Valadon, on Boulevard Montmartre. Vincent hoped to share his brother's apartment and learn what was happening in art from its location at the center of that world. What was this new thing called "Impressionism," and what was the meaning of its revolution of color and atmosphere? While taking classes briefly at Fernand Cormon's Paris art studio, thirty-three-year-old Vincent met fellow student Émile Bernard, who was eighteen. Émile was known for being both brash and brilliant. Vincent, sick of the cold weather, alcohol, and arguments among the Paris artists, left the city two years later. But even as he headed for the heat and light of Provence to be among the peasants in the south of France, he kept up his friendship with Émile Bernard through letters. This

would be the same man with whom Vincent shared his views on religion and art in Letter 632.

Deeply impressed by the twenty-two or more letters he received from Vincent, Bernard worked diligently to have them published after Vincent's death. He introduced readers to the author of the letters, with the following words: "[Vincent] was the noblest human character one could meet: frank, open, alert to the possible, with a certain trace of comical mischievousness; an excellent friend, an implacable judge, utterly without egoism or ambition, as his so simple letters show, in which he is as much himself as in his countless canvases." It was through those published letters to Émile that many met Vincent van Gogh for the first time.

Below, a passage from Vincent's letters to Bernard gives us a candid view of Vincent's attempt to advise his talented, argumentative friend. He hopes to convince the young, restless Bernard that understanding himself and focusing his creativity on what is closest to him make up the most promising path in life and in art. Bernard's restless search for something exotic and mystical—symbols from Italian art or the Near East, or medieval Catholic Church decorations, something far from home and far from the familiar—would, in fact, lead him away from Vincent's creative focus, in spite of his friend's advice.

One creative who took to heart Van Gogh's secret of "what is nearest" was the famous German poet Rainer Maria Rilke, who discovered Van Gogh's work when a friend showed him a portfolio of the painter's prints in Paris in 1907. Rilke, after seeing the prints, wrote a letter to his artist wife in Germany, saying, "I believe I do feel what van Gogh must have felt at a certain juncture, and it is a strong and great feeling: that everything is yet to be done: everything. But this devotion to what is nearest, this is something I can't do as yet, or only in my best moments, while it is at one's worst moments that one really needs it."

As he encountered Vincent's work, Rilke discovered his secret for dealing with life's difficulties and promises: the spiritual path moves through the very field that is nearest to you, and so is never exhausted. If the depth of spiritual meaning were not available in that nearby peasant hut, that field of wheat, that garden, then it would not be worthy of the artist's search and struggle. As one of the parables of Jesus reveals, the "hidden treasure" is buried right in the field you are plowing. This truth is something Vincent

stated very simply to Theo: "Let's do the possible, what's right in front of us" (Letter 621).

Vincent to Émile Bernard, Letter 655

Arles, August 5, 1888

In the first place, I must speak to you again about yourself, about two still lifes that you've done, and about the two portraits of your grandmother. Have you ever done better, have you ever been more *yourself*, and someone? Not in my opinion. Profound study of the first thing to come to hand, of the first person to come along, was enough to really *create* something. Do you know what made me like these 3 or 4 studies so much? That *je ne sais quoi* of something deliberate, very wise, that *je ne sais quoi* of something steady and firm and sure of oneself, which they show. You've never been closer to Rembrandt, my dear chap, than then.

For Reflection

Vincent urged his young artist friend Bernard, who sought to paint exotic things in far-off lands, to focus rather on the success of painting his grandmother in the family home. Vincent believed that finding deepest meaning in what is nearest is the true test of spiritual discernment.

For Creative Engagement

Read Thornton Wilder's *Our Town* set in the fictional town of Grovers Corners, New Hampshire, in 1901. The play's young mother, Emily Webb, learns through death how close meaning actually was every day, and advises us to wake to that realization. She asks, "Do any human beings ever realize life while they live it? — every, every minute?"

Work as the Nightingale Sings

Even in the midst of the
beautiful landscapes of Arles
in southern Provence, Vincent
sought out occasions for
painting portraits. His sense
that the "modern portrait"
held the future hope of
art continued to grow in
his imagination. Having
left brother Theo's Paris
apartment in late February
of 1888 and rented the Yellow House in Arles by the first of
May, Vincent had been in an ecstasy as he painted the season
of flowering trees and then the ripening wheat fields and
the harvest. By the time of this letter sent in August, he is
excited to describe his attempts at southern portraits.

He begins with his portrait of a peasant named Mr. Patience Escalier "in the very furnace of harvest time," even as he faults Parisians for not understanding persons so close to the earth and so burned by the sun. He also wonders how his portrait of his friend the postman, a revolutionary he saw "singing the Marseillaise," will be understood by the Paris set of artists.

Finally, he goes on to describe quite another portrait, turning his attention now to the description of a poet seen among the night sky and its stars, a portrait of the young Belgian artist Eugene Boch, who had visited him. His description, which follows, gives us a revealing experience of Vincent's manner and intent in painting. He, in a real sense, "tells" us a painting as we might tell someone a story, and as we might allow the story to develop and move the hearer. Certainly, this reveals to us the close relationship of Vincent's words in letters to his paintings on canvas. Boch, on his part, listened to Van Gogh's ideas and went on, inspired to paint in the Belgian Borinage mining district. It was, not coincidentally, Eugene Boch's sister, also a Belgian painter, who made the one significant purchase of a Van Gogh painting in his lifetime. For 400 francs she purchased his *Red Vineyard* when it was shown in Belgium.

A careful look at one of the three Van Gogh paintings of his bedroom in the Arles Yellow House shows that he hung the painting he did of Eugene Boch, as *The Poet*, over his bed.

Vincent to Theo, Letter 663

Arles, August 18, 1888

I'd like to do the portrait of an artist friend who dreams great dreams, who works as the nightingale sings, because that's his nature.

This man will be blond. I'd like to put in the painting my appreciation, my love that I have for him.

I'll paint him, then, just as he is, as faithfully as I can—to begin with.

But the painting isn't finished like that. To finish it, I'm now going to be an arbitrary colourist.

I exaggerate the blond of the hair, I come to orange tones, chromes, pale lemon. Behind the head—instead of painting the dull wall of the mean room, I paint the infinite.

I make a simple background of the richest, most intense blue that I can prepare, and with this simple combination, the brightly lit blond head, against the rich blue background achieves a mysterious effect, like a star in the deep azure.

For Reflection

Vincent's deep work of imagination before painting a fellow artist's portrait becomes clear as he describes his planned portrait of his friend as a poet "who works as the nightingale sings," seen in the night sky among its stars. The portrait of Eugene Boch later appears above Vincent's bed in his painting of his bedroom in Arles. See how one powerful image can join and shed light on another in meditative ways. It is not unlike the images you find mingling in your creative dream-life.

For Creative Engagement

Vincent describes his poet friend as one "who dreams great dreams, who works as the nightingale sings, because that's his nature." Do you open yourself at night to dreaming great dreams that express your nature, your work, your imagination? Dreamwork can uncover our deepest gifts, the songs of our soul. Do you trace your dreamwork in a journal? Try conversing with your dreams, asking them to become guides to the hidden seeds that are ready to grow and blossom, binding your active days with your meditative rest and inner exploration.

Something of the Eternal

The great Columbia University art critic, Meyer Shapiro, spent his career at the university devoting himself to teaching, writing, and becoming a philosopher and world scholar in the arts. Beloved by many of the great modern artists working in New York City, as well as by art historians worldwide, his 1950 classic, *Van Gogh*, a work of just over one hundred pages, reveals one of the groundbreaking successes of Van Gogh's lifework, his creation of the "modern portrait."

While many are moved by Van Gogh's images of fields, sky, trees, the sea, and flowers, Meyer Shapiro's keen observations of the faces of Vincent's portraits of women and men, including his own self-portraits, confirm that these works were some of Van Gogh's most original gifts to art and

culture. Shapiro refers to Vincent's portraits as "an unexpected revelation." He tells us that Van Gogh's people "are portrayed with the same unfailing sympathy, but also with a penetrating realism, an insight into the wear and tear of life. These are the first democratic portraits and would have pleased Whitman especially. They have no real forerunners in old art." Most portraiture at the time belonged to and reflected the wishes of the privileged, the powerful, and the wealthy. With Van Gogh, sitters were straight from the fields and streets he walked, invited to sit as an act of simple hospitality, portrayed with the new freedom and depth he had discovered for his brushstrokes and colors. Vincent himself noted that the closest kin to his portraits were the bright medieval portraits of early Christian saints. And viewing the portraits in that light, we see that Van Gogh's portraits seek the inner life of the humans he lived among and viewed as individuals in the larger context of eternity.

Vincent to Theo, Letter 673

Arles, September 3, 1888

Ah, my dear brother, sometimes I know so clearly what I want. In life and in painting too, I can easily do without the dear Lord, but I can't, suffering as I do, do without something greater than myself, which is my life, the power to create. . . .

And in a painting I'd like to say something consoling, like a piece of music. I'd like to paint men or women with

that *je ne sais quoi* of the eternal, of which the halo used to be the symbol, and which we try to achieve through the radiance itself, through the vibrancy of our colorations. . . .

Ah, the portrait—the portrait with the model's thoughts, his soul—it so much seems to me that it must come.

For Reflection

Do you focus, as many do, on Vincent's paintings of fields, orchards, olive groves, and starry skies? They are well worth our focus, but Vincent is as quick to point out the importance of portraits, whose faces glow with "[something] of the eternal, of which the halo used to be the symbol."

For Creative Engagement

Do you view the faces around you each day so attentively that they reveal the hidden soul? Seek today to meet others soul-to-soul, a sharing of the eternal in each of us. Creative a record of that meeting in your artform. As you do, consider "that *je ne sais quoi* of the eternal."

ILLUMINATION 23

A Mystical New Art in Jarring Colors

Vincent van Gogh's art, in both painting and letters, forms a kind of spiritual autobiography and provides both viewers and readers creative works of light and spiritual sustenance. One of the deepest experiences of Vincent's spiritual search came when he spent three nights painting the Night Café, which was the ground floor of the building where he rented a room before moving into the Yellow House (a space he hoped would be a community, or a "monastery," for poor painters).

The Night Café was run by Joseph and Marie Ginoux, and was a space that Vincent tells us stayed open all night and became home to the poor, the outcasts, the "night prowlers" who had no other place to sleep. He wrote to Theo in August, "Today I'm probably going to start on the interior of the café where I'm staying, in the evening, by gaslight. It's what they call a 'night café'. . . that stay [*sic*] open all night. This way the 'night prowlers' can find a refuge when they don't have the price of

a lodging, or if they're too drunk to be admitted" (Letter 656). However, not until September did he begin the actual painting.

On September 4, 1888, he set up his easel in the café and spent the next three nights creating what he called his "ugliest" painting. Yet he also came to consider it one of his most important paintings, comparing it with his earlier *Potato Eaters* and describing it for Theo in the passage quoted below from a letter on September 8.

The Night Café became a refuge for Vincent after a long day of painting, and perhaps he regularly sat at one of those tables among the homeless as they slept. One study for the *Night Café* painting shows the viewer invited in among the poor and dispossessed, whose doorway has the shape of a Jesus-image, similar to popular religious paintings of Vincent's day.

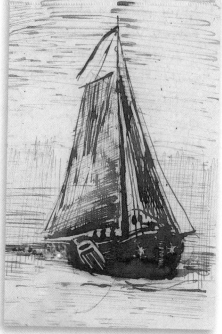

Interesting in Vincent's description of the work is the "battle" of the colors in his painting of the café, where he compares that clash with Delacroix's painting of Christ in a boat on the stormy

Sea of Galilee, comforting his disciples. The sense of danger and unsettling forces, yet the promise of consolation, played a key role in Vincent's thinking, his approach to religion, and his approach to doing art.

One of Vincent's most quoted Scripture passages comes from the apostle Paul in 2 Corinthians: "We are treated as impostors, and yet are true; as unknown, and yet well known; as dying, and behold, we live; as punished, and yet not killed; as sorrowful, yet always rejoicing; as poor, yet making many rich; as having nothing, yet possessing everything" (6:8–10 ESV). In Vincent's own life among the poor artists, peasants, and laborers, the parallel is striking. Vincent creates a new art rejected by the establishment, an art of miners and weavers struggling in a world where owners of mines and manufacturing companies were wealthy and powerful. Through these portraits Van Gogh struggled to understand and heal the antitheses of life, to find a coincidence of opposites that might merge in some mystic unity in a broken world. For Vincent, even the use of the jarring meeting of complementary colors sought to effect some healing unity.

Vincent to Theo, Letter 676

Arles, September 8, 1888

I'd given a piece of my mind to the said lodging-house keeper, who isn't a bad man after all, and I'd told him that to get my own back on him for having paid him so much money for nothing, I'd paint his whole filthy old place as a

way of getting my money back. Well, to the great delight of the lodging-house keeper, the postman whom I've already painted, the prowling night-visitors and myself, for 3 nights I stayed up to paint, going to bed during the day. It often seems to me that the night is much more alive and richly coloured than the day. Now as for recovering the money paid to the landlord through my painting, I'm not making a point of it, because the painting is one of the ugliest I've done It's the equivalent, though different, of the potato eaters.

I've tried to express the terrible human passions with the red and the green.

The room is blood-red and dull yellow, a green billiard table in the centre, 4 lemon yellow lamps with an orange and green glow. Everywhere it's a battle and an antithesis of the most different greens and reds; in the characters of the sleeping ruffians, small in the empty, high room, some purple and blue.

For Reflection

Vincent spent three nights painting the Night Café near the Arles railroad station. Because it was open all night, the café became a refuge for the poor and dispossessed, and what Vincent called "night prowlers." To catch the spirit of that strange and perhaps dangerous space, Vincent used jarring greens and reds, pulsing yellow gaslights, and mystical reflections on walls and in mirrors. He may well have had in mind the parable in Luke's Gospel that

advised one to invite to a feast "the poor, the maimed, the lame, the blind, and you will be blessed" (Luke 14:13 NKJV). Where do the dispossessed of your town find refuge? Do you need some "Vincent" to introduce you to how the "others" of our society or your city or small town spend their nights?

For Creative Engagement

Every society has its hidden side where those who live on the margin seek some refuge. Vincent himself lived most often on that margin, and reminds us of its jarring atmosphere—and perhaps also of the blessings offered those who invite such persons to their table in one manner or another. A New Testament writer tells of the possibility of showing hospitality to angels unaware (Hebrews 13:2). Is this what Vincent had in mind? Consider what that hospitality might mean for others. What refuge might you feel called to offer in the margins?

The Bedroom in Arles: Looking at What Is Nearest for Our Next Creative Task

It has become popular for museums owning a Van Gogh painting to organize an exhibition around that work, borrowing art from other museums to fill out a meaningful context for their Van Gogh canvas and explore some corner of the artist's interests and creativity. Most of these exhibits offer a related catalogue or book. *Van Gogh's Bedrooms*, edited by an Art Institute of Chicago curator, Gloria Groom, is such a volume. The Art Institute's own *Van Gogh's Bedroom* painting is joined by the other two versions of this painting, borrowed from Amsterdam's Van Gogh Museum and the Paris d'Orsay. From February to May of 2016, all three "bedroom paintings" were on exhibit.

What might the viewer of *Van Gogh's Bedroom* see? We are given an intimate look into a room empty of humans but filled with a simple workman's humanity. There is a small wooden

table with the simplest of objects. In the background is one closed window. In the room itself are very plain rush-bottom chairs, and a solid, unpainted wooden bed with white or green or yellow pillows and a red blanket. Behind the bed hang work clothes and a straw hat. A variety of artworks cover the wall over the bed, and the entire canvas is painted basically in two sets of complementary colors, yellow and violet/lilac; red and green.

As we view this simple second-floor bedroom just outside Arles, we glimpse a representation of Vincent's fondest hope that he has finally found a safe haven. After all, by age thirty-four, he had already lived in over thirty rented or borrowed rooms in four countries. Now, in this simple room nested in the same Mediterranean sun his artist heroes Delacroix and Monticelli enjoyed, we have a sense of "home." Might this be a home base where a failed art clerk, a failed evangelist, might discover a

deep and consoling art among peasant laborers and their fields
of wheat, olive orchards, and kitchen gardens? Or is Vincent
a perpetual wanderer whose inner life will remain invisible to
others, ourselves included? What the bedroom paintings offer
us is evidence that Vincent, temporarily exhausted with constant
painting in the fields, found rest and recovery in that wooden
bed, and that when he awoke, he turned to paint the first thing he
saw: his bedroom. Perhaps we are invited to feel his gratitude to a
room and bedstead; perhaps we are invited by Van Gogh to look
at what is nearest us for our next creative task.

In the book *Hermeneutic Philosophy of Science, Van Gogh's Eyes,
and God*, edited by Babette Babich, Jesuit theologian and scientist
Patrick Heelan shares his experience of the "bedroom painting":

> I was early fascinated by the realism of Van Gogh's
> paintings, particularly of his Bedroom at Arles (1888)
> which I had seen at the Chicago Art Institute and
> which gripped me with the experience of a transfixing
> presence that I can only describe as being in that room.
> . . . I took a course on Riemannian geometry given
> by Erwin Schrödinger at the Dublin Institute for
> Advanced Studies in the late forties. During the course
> he raised the question: was it possible to see — or at least
> imagine — a non-Euclidian or Riemannian world?

Heelan unpacks his comments, suggesting that Vincent's
unique vision of the space of his bedroom is related to the "finite

but unenclosed space" Einstein envisioned, where elliptical space curves in on itself and merges with time. According to Heelan, were we to open that window in the painting, there would be nothing at all outside it. All space/time empties itself in a present moment in the immediacy of Van Gogh's vision of the vibrating colors of a consoling space we experience completely.

Vincent to Theo, Letter 705

Arles, October 16, 1888

My eyes are still tired, but anyway I had a new idea in mind, and here's the croquis of it. No. 30 canvas once again.

This time it's simply my bedroom, but the colour has to do the job here, and through it's being simplified by giving a grander style to things, to be suggestive here *of rest* or *of sleep* in general. In short, looking at the painting should *rest* the mind, or rather, the imagination.

The walls are of a pale violet. The floor—is of red tiles.

The bedstead and the chairs are fresh butter yellow.

The sheet and the pillows very bright lemon green.

The blanket scarlet red.

The window green.

The dressing table orange, the basin blue.

The doors lilac.

And that's all—nothing in this bedroom, with its shutters closed.

For Reflection

Vincent shares with us a view of his bedroom in the Yellow House in Arles. When he awoke one morning, the first thing that he saw became the task at hand. He shows us his bedroom, and suggests his gratitude for the simple gift he had just received: a night's rest.

For Creative Engagement

Not only are we reminded how close to us our next task might be, but we are awakened to the simple gifts that restore us each night. Who stops to offer thanks for a safe space to sleep, for hours of restoration, dreams, comfort? Make a plan to begin your next day by gathering the night's dreams and thanking your bedroom for the privilege of restful sleep. Then find that nearest task that calls for your attention.

Repetition: A Life Practice

Vincent painted Augustine Roulin, wife of his friend Joseph Roulin, a postal worker, five times. Augustine Roulin was born in 1851, two years before Van Gogh, but would live on forty years after the artist's death. In the Roulin home in Marseille, Vincent's portraits of Joseph, Augustine, and their children once hung proudly, gifts from the artist. Joseph Roulin had been Vincent's best friend in Arles. He befriended the strange Dutch foreigner and helped him find his way in the unique southern culture of Arles. He allowed Vincent, who always had difficulty finding models, to paint every member of his family. Among the most famous of those family portraits are the five versions of Augustine as "La Berceuse," which Vincent hoped would be viewed as his "singing a lullaby in color." Vincent offered two of the repetitions of the painting to the artists Gauguin and Bernard, after allowing Augustine herself to select her favorite for her own home.

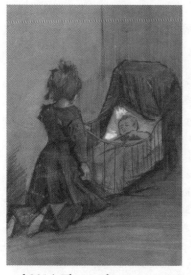

Repetition became a life practice for Vincent. Such repetition is far more than attempting to "memorize"; it is the deeper practice suggested by the French term *par coeur*: learning "by heart." The seriousness of Vincent's use of repetition in his art may be illustrated for us in the exhibition catalogue titled *Van Gogh Repetitions* that accompanied the Phillips Collection and the Cleveland Museum of Art shows in 2013 and 2014. The catalogue contains several fascinating essays on repetition as a practice.

The *La Berceuse* paintings offer the attentive viewer connections and questions. Note how Vincent placed the new mother in her rocking chair with a backdrop of brightly flowered wallpaper, suggesting that families are part of nature's own rich blossoming. Ask the "cradle rocker" where the child is, and see if the visual absence of the baby allows the artist to put us, the viewers, in that hidden cradle attached to the rope in her hand. Is this one of Vincent's most spiritual works, relating birth, motherly care, and vulnerability together as a new way of seeing and so imaging God, religion, and eternity? See how the repetitions evoke God as the vulnerable child in

the Christmas cradle.

Years before his painting of the Berceuse and her hidden cradle, Vincent created artwork around another cradle, when he took an ill woman to the hospital and then into his studio in The Hague and found a used cradle for her new child. He described his rented space this way for Theo in July of 1882: "Then the little living room with a table, some kitchen chairs, a paraffin stove, a big wicker armchair for the woman in the little corner by the window overlooking the yard and meadows familiar to you from the drawing, and next to it a small iron cradle with a green coverlet. I can't look at the last piece of furniture without emotion, for it's a strong and powerful emotion that grips a person when one has sat beside the woman one loves with a child in the cradle near her. And even if it was a hospital where she lay and I sat with her, it's always that eternal poetry of Christmas night with the baby in the manger as the old Dutch painters conceived of it, and Millet and Breton— — —that light in the darkness—a brightness in the midst of a dark night" (Letter 245).

The following passage from Vincent's letter to Theo in January of 1889 from Arles may affirm such meanings, as Vincent himself pictures the painting as a religious triptych for a fishing boat with the Virgin Mary and her child, patron saints of fishermen, in the cabin, as the boat sails on a more dangerous sea than that of Galilee.

Vincent to Theo, Letter 743

Arles, January 28, 1889

I think I've already told you that in addition I have a canvas of a *Berceuse*, the very same one I was working on when my illness came and interrupted me. Today I also have 2 versions of this one.

On the subject of that canvas, I've just said to Gauguin that as he and I talked about the Icelandic fishermen and their melancholy isolation, exposed to all the dangers, alone on the sad sea, I've just said to Gauguin about it that, following these intimate conversations, the idea came to me to paint such a picture that sailors, at once children and martyrs, seeing it in the cabin of a boat of Icelandic fishermen, would experience a feeling of being rocked, reminding them of their own lullabies. Now it looks, you could say, like a chromolithograph from a penny bazaar. A woman dressed in green with orange hair stands out against a green background with pink flowers. . . . I can imagine these canvases precisely between those of the sunflowers—which thus form standard lamps or candelabra at the sides, of the same size; and thus the whole is composed of 7 or 9 canvases.

For Reflection

Vincent painted Augustine Roulin, wife of his friend Joseph Roulin, a postal worker, five times. Each repetition was a new work of discovery. Vincent viewed this contemporary saint rocking her baby girl as his "singing a lullaby in color." How might reflecting on these repeated attempts by Vincent to discover the "soul" of a mother inspire your own practice of repetition as a search for deepening meaning through compassionate exploration?

For Creative Engagement

Make your own exploration of the portrait of Augustine Roulin as cradle-rocker. Does the blossoming wallpaper add to the sense of new life hidden in that invisible cradle? If you don't have a book of Vincent's paintings that show the set, you might find them online. Viewing each of Vincent's five versions of the painting, can you follow the artist's attempt to discover Augustine's feelings as she rocks that hidden cradle? Is she dreaming of the new life she has birthed? Is her Lullaby a creation hymn shared with you? Put a copy of one of those paintings in a place where you can view it day after day. Does continued attentiveness reveal more and more of mother Roulin, more and more of the artist who painted her, and perhaps more and more of you as the viewer?

By Liking a Thing, One Sees It Better

On May 8, 1889, Vincent had himself admitted to the Saint-Paul-de-Mausole asylum in Saint-Rémy. In the asylum assessment records, Dr. Peyron wrote, "I consider that Mr. Van Gogh is subject to attacks of epilepsy."

On May 9, his second day at the asylum, Vincent appears anxious to allay Theo's fears. Almost four hundred miles away in Paris, Theo had expressed his worries about whether an asylum, with its patients, is a wise place for Vincent during his illness. Vincent writes in this first asylum letter to Theo and his wife Johanna: "I wanted to tell you that I think I've done well to come here, first, in seeing the *reality* of the life of the diverse mad or cracked people in this menagerie, I'm losing the vague dread, the fear of the thing. And little by little I can come to consider madness as being an illness like any other. Then the change of surroundings is doing me good, I imagine."

In this same letter, Vincent addresses Johanna directly, with a keen sense that he has for understanding his new sister-in-law's concerns, and assures her of the importance of her positive presence for his brother's life. His words demonstrate an awareness of the matters that might worry a young woman from a close-knit Dutch family as she enters the busy world of the arts and business, finds she has a brother-in-law in an asylum, and moves into an apartment close by the confusion of Montmartre in the city of Paris. Vincent directly assesses the challenge of adjusting and makes clear the promises her new relationship offers. But he adds a deeper sense of what loving Paris can mean, as well as a deeper appreciation of what her presence means to Theo. And with all this, Vincent makes it clear he is quite willing to reveal his puzzlement over his own situation and to share his uncertainties with her.

Vincent to Johanna, Letter 772

Saint-Rémy-de-Provence, May 9, 1889

My dear sister,

. . . I can see that you have already observed that [Theo] loves Paris and that this surprises you a little, you who don't like it, or rather who above all like the flowers there, such as, I suppose, for example, the wisterias which are probably beginning to flower. Could it not be the case that in liking a thing one sees it better and more accurately than in not liking it. . . .

All this to urge you—with all caution, admittedly—to believe in the *possibility* that there are *homes* in Paris, and not just apartments.

Anyway—fortunately *you* are now his home yourself.

It's quite odd perhaps that the result of this terrible attack is that in my mind there's hardly any really clear desire or hope left, and I'm wondering if it is thus that one thinks when, with the passions somewhat extinguished, one comes down the mountain instead of climbing it. Anyway my sister, if you can believe, or almost, that everything is always for the best in the best of worlds then you'll also be able to believe, perhaps, that Paris is the best of the towns in it.

For Reflection

Vincent must have heard from brother Theo that his new Dutch wife was unhappy in the foreign and confusing city of Paris. Though Vincent was struggling to adjust to his second day in an asylum, he displays admirable wisdom and compassion in assuring Johanna that if she can share Theo's love of Paris, she may well see it in a new and comforting light. Further, he reminds her that in a real sense, she is now Theo's home, as he is hers.

For Creative Engagement

Do we now see how profound the wisdom and love of Vincent can be? New to his asylum, he attends to the needs of a sister-in-law he has never met, and uncovers for her and for us the truth that loving something allows us to see it better, and that our home, in reality, is in the one we love. Can you find in your experience the truth and comfort in Vincent's words to Johanna? Does Vincent suggest a way you might "see better" by sharing another person's likes, and see another person as a comforting space?

Starry Night: Remaining Open to the Infinite

To get a sense of the significance and scope of Vincent's painting we call *Starry Night*, we need to piece together bits of his correspondence. There is no one luminous passage by the artist that describes this work in Vincent's letters. There is no congratulatory passage by Theo to Vincent when this particular painting arrives in Paris. Even after Vincent's death, there is no celebration of the work as a special icon that marks the artist's genius. In fact, this is not a painting that Theo or, at Theo's death, Johanna cared to keep in the collection of Vincent's paintings. And that is one reason *Starry Night* does not reside in the Van Gogh Museum, which houses the collection the Van Gogh family kept. Even after passing from one owner to another, upon being offered for sale to New York's Museum of Modern Art, it was at first refused and only acquired by MOMA in 1941. For decades it was not even hung in a gallery to be seen by the public.

What are we to make of this strange life of a now world-renowned painting?

A place to start may be a letter by Vincent to his young friend Émile Bernard, who remained in the north of France. Van Gogh writes to Bernard from Arles on June 19, 1888 (Letter 628), praising the south of France and its Mediterranean sunshine, its chrome-yellow sky, sun, and wheat fields. He writes, "I even work in the wheatfields at midday, in the full heat of the sun. . . . I revel in it like a cicada. My God, if only I'd known this country at 25, instead of coming here at 35." He mentions his "snatches of memories from past times, yearnings for that infinite of which the Sower, the sheaf, are the symbols" that "still enchant me as before." Throughout his letters the yellow sun and wheat remain among Vincent's chief symbols of the infinite in his memory and in the reality of Provence.

But in that same letter Vincent asks, "But when will I do the starry sky, then, that painting that's always on my mind?" Along with the infinite in the sun and wheat fields, the starry sky is also in his thoughts. After asking that question, Vincent will go on to include starry skies in several paintings, but it is his rendering of the swirling night sky of stars and moon seen from the asylum, now housed in New York's Museum of Modern Art, that has become a focus of attention in our day.

It is the painting that opens the film *Loving Vincent*, it is the subject of Don McLean's song "Starry, Starry Night," and it is the Van Gogh painting often featured on book covers and posters and coffee cups in our day.

Was that particular *Starry Night* Vincent's answer to his wish for a starry sky? Stars certainly are an element of the infinite he experienced and connected deeply to his religious feelings, even as he saw the infinite available everywhere if one is open and sensitive to it. In an early letter to Theo back in 1882, from The Hague, Vincent writes:

> Yet if one has the need for something great, something infinite, something in which one can see God, one needn't look far. I thought I saw something—deeper, more infinite, more eternal than an ocean—in the expression in the eyes of a baby—when it wakes in the morning and crows—or laughs because it sees the sun shine into its cradle. If there is a 'ray from on high', it might be found there. (Letter 292)

So we must remain open to the infinite as available in many places, and perhaps especially available among the poor, the powerless, as in Vincent's memory of the child of a penniless prostitute in his shabby studio in The Hague. So yes, the infinite in the starry sky and the infinite in a field of wheat in the sun of Provence, or in a child in its cradle, moves Vincent deeply as an artist and as a spiritual seeker. There is not simply the riddle of the stars, or even the stars and the wheat field. "Reality" itself is at the center of this riddle within a riddle. As Vincent, in that same letter of 1882, mused with Theo, "When you say in your

last letter 'what a riddle there is in nature', I echo your words. Life in the abstract is already a riddle, reality turns it into a riddle within a riddle."

But let's return to the reference to that most popular *Starry Night* painting done at the asylum. Neither Vincent nor Theo calls it "Starry Night," and in fact it could be viewed as focusing in part on the lights in the cottages of a village nested beside the Alpille Mountains and built around a church steeple. It also features the tall cypress trees that so attracted Vincent—trees that seem to join the earth to the sky.

Theo, and perhaps Vincent, feels that the painting with the swirling lights might be suspect, an exaggeration, a departure from Vincent's normal focus on our earthly reality. When Theo receives the painting of *Starry Night*, his focus isn't on the sky; he calls the painting "the village in the moonlight" (Letter 813). Theo tells Vincent that in his view, the painting's "search for style takes away the real sentiment of things." He writes, "I consider that you're strongest when you're doing real things." Was the painting indicating Vincent leaning too heavily toward the symbolist creed of Gauguin and Bernard that asks artists to trust their imaginations, to paint ideas, to close their eyes before nature and dream their paintings, rather than go into nature and record it? Did Theo see the painting as an indication that Vincent's direct engagement with nature and human life in that village was now an imaginative dreaming of an ill painter in an asylum and prone to seizures?

We have not solved the place of *Starry Night* in Van Gogh's view of his work. But putting his miners, weavers, potato farmers,

and nursing mothers into the wider context of the larger—real, yet infinite—world, we can view each cottage under that night sky, inhabited by families struggling with daily problems and enjoying life's surprise smiles, as presenting the infinite to those who pay attention.

Vincent to Theo, Letter 782

Saint-Rémy-de-Provence, June 18, 1889

At last I have a landscape with olive trees, and also a new study of a starry sky.

Although I haven't seen the latest canvases either by Gauguin or Bernard, I'm fairly sure that these two studies I speak of are comparable in sentiment. When you've seen these two studies for a while, as well as the one of the ivy, I'll perhaps be able to give you, better than in words, an idea of the things Gauguin, Bernard and I sometimes chatted about and that preoccupied us. It's not a return to the romantic or to religious ideas, no. However, by going the way of Delacroix, more than it seems, by colour and a more determined drawing than *trompe-l'oeil* precision, one might express a country nature that is purer than the suburbs, the bars of Paris. One might try to paint human beings who are also more serene and purer than Daumier had before him.

For Reflection

Has Vincent captured the sense of mystery that the night sky has held for humans over the ages? Until we look up at the stars, we easily forget our small place in an unimaginably huge and mysterious universe. Are you drawn to the night sky? What secrets does it hold regarding the immense setting within which we live our life?

For Creative Engagement

What better way is there to understand Vincent's art than by simply walking out into the darkness tonight and staring at the night sky? Make a plan to view the night sky from a variety of settings, hopefully away from the distraction of electric lights. Walking a deserted beach with its far horizon and raising your gaze slowly toward the stars, maybe you will replicate something of Vincent's view from the dark countryside where his asylum was located. And do spend time studying that painting he and Theo puzzled over. Note that the painting begins with the tiny lights in peasant homes Vincent called "nests," and then extends in cypress trees toward the heavens. Do you share the mystery of the infinite as the artist experienced it?

Finding Creation Spirituality in a Wheat Field

The attraction of the Bible and its images for Van Gogh became a significant part of his life from his early years in a Dutch Protestant parsonage. But as he moved out into the world and sought to put Dutch spirituality into practice, he became disillusioned with the religious institutions of his day. His Dutch Reformed pastor–father refused to consider the value of much of the spirituality to be found in the new poetry, literature, and art that so moved his son. When Vincent's attempt to serve miners as an evangelist in the Belgian Borinage region was met with official rejection by a Board of Evangelism, he saw "official" Christianity of the church as unwilling to take seriously its responsibility to the laborers, the peasants, and the earth. Being rejected by religious authorities led Vincent to seek out new ways of integrating religion and literature, and religion and the arts, as he began

to develop a spirituality of the lives of the marginalized and a religion of caring for the earth and its creatures. His spirituality might be considered a forerunner of what today is called by many names—ecological theology, spiritual ecology, or creation spirituality. We see spiritual offspring of Van Gogh that include artists, but also writers such as Matthew Fox (*Creativity*), Wendell Berry (*Our Only World*), and Kristin Swenson (*God of Earth: Discovering a Radically Ecological Christianity*).

An important theme in Vincent's art was the wheat fields and the peasants who worked in those fields. His year in the asylum at Saint-Rémy in Provence gave him opportunity to view a single wheat field through a full life cycle over the course of an entire year. Through the bars on the window of his asylum bedroom, he saw that same field being plowed, being planted, growing the young grain, in rain and sun, tossed by the mistral winds, and finally being harvested by a peasant cutting the stems with a sickle and gathering them together into sheaves. That experience of living through the lifetime of wheat and

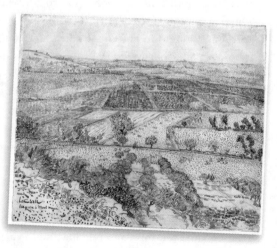

peasant labor in one field had a deepening effect on Vincent's view of earth's wheat and peasants as fellow creatures with himself. Wheat was both reality and a symbol of the cycle of life, and in his art and thought, Vincent explored the meaning of this cosmic reality in many forms.

Earlier in his work as artist, while developing his approach to painting in the village of Nuenen, Vincent expressed to Theo his linking of "all reality" and symbolism in this manner and named some of the artists he admired for teaching him to make that link. He wrote: "As for Poussin—he's a painter who thinks and makes one think about everything—in whose paintings all reality is at the same time symbolic. In the work of Millet, of Lhermitte, all reality is also symbolic at the same time" (Letter 533). Vincent embraced this sense that thinking itself was a part of great art, that philosophy and culture joined in a deepening of the act of painting, a sense for the unity of each "reality" with and within the infinite.

Regarding Van Gogh's pioneering views on an earth-centered religion and its symbolisms, there is much more to say. But for now, we will let two passages in his letters to Theo, both relating human life and earth's wheat fields, speak for themselves.

Vincent to Theo, Letter 800

Saint-Rémy-de-Provence, September 6, 1889

I'm struggling with a canvas begun a few days before my indisposition. A reaper, the study is all yellow, terribly thickly impasted, but the subject was beautiful and simple.

I then saw in this reaper—a vague figure struggling like a devil in the full heat of the day to reach the end of his toil—I then saw the image of death in it, in this sense that humanity would be the wheat being reaped. So if you like it's the opposite of that Sower I tried before. But in this death nothing sad, it takes place in broad daylight with a sun that floods everything with a light of fine gold. Good, here I am again, however I'm not letting go, and I'm trying again on a new canvas. Ah, I could almost believe that I have a new period of clarity ahead of me.

Vincent to Theo, Letter 805

Saint-Rémy-de-Provence, September 20, 1889

Do you know what I think about quite often—what I used to say to you back in the old days, that if I didn't succeed I still thought that what I had worked on would be continued. Not directly, but one isn't alone in believing things that are true. And what does one matter as a person then? I feel so strongly that the story of people is like the story of wheat, if one isn't sown in the earth to germinate there, what does it matter, one is milled in order to become bread.

The difference between happiness and unhappiness, both are necessary and useful, and death or passing away . . . it's so relative—and so is life.

For Reflection

Vincent's paintings make clear that he spent many of his days standing in wheat fields. Have you ever seen the Kurosawa film called *Dreams*? One dream sequence pictures an art student actually entering a Van Gogh painting in search of the artist. He, of course, finds Vincent painting in a wheat field. Wheat fields have provided humans with "the bread of life" for ages. Vincent found sowers and reapers to be among his chief symbols for life's own seedtime and harvest. He came to think of human love as equivalent to the power of germination in wheat, and human death as a harvesting to gather the seed and bread for the next generation.

For Creative Engagement

Vincent has paintings and sketches that focus on just a few stalks of wheat, and others that provide a wide panorama of wheat fields stretching to the horizon. He painted new green sprouts, and sheaves of gathered wheat. Can you find an opportunity to actually walk around a field of growing wheat? If not, study one of Vincent's many wheat paintings to meditate on our kinship with wheat. Visit a bakery that creates loaves of bread, or better yet, bake a loaf from ground wheat and share it, as it shares its life with you.

ILLUMINATION 29

Brush and Bow: The Physicality of Artmaking

In the asylum at Saint-Rémy, Vincent had several major attacks, described by the attending doctor as "epileptic seizures." These seizures left him for a time weak, confused, and depressed. He generally could not remember what he did during the seizures, but apparently there were attempts to poison himself by eating paint and drinking turpentine. But when Vincent was lucid, he wanted to get back to his painting, and discovered that painting "copies" of works by artists he admired brought him consolation and healing. Yet he wondered if painting such copies lacked creativity and might be viewed negatively. His struggle with the issue continued through many letters to Theo, and at last he decided to stop "copying."

The letter extract on "copying" provides a fascinating look at the task. We learn how much intense concentration and energy were required for Vincent to "compose" an original painting even as working from the images of favorite artists seemed to

bring relaxation, consolation, and healing. Vincent explores creative approaches to his understanding of what a copyist does and raises important questions: Is making an oil painting in color from a black-and-white print really copying, or is it "translating"? Does it provide some meaningful decoration and a sort of homage to other artists if kept in one's own studio for inspiration?

As he considers the work in this light,

Vincent's description of his brush on a canvas as being like the bow on a violin emphasizes his realization of the close relation of even the physicality of all art-making. Perhaps his choice of materials—of a rougher linen

canvas showing the work of laborers in the fields, for instance —
extends that sense of artistry to the tasks/arts of ordinary
peasants.

Van Gogh's struggle to deepen the meaning of "copying"
has relevance for creatives who see value in collaborative work
and group activities, or seek new definitions of *creativity*. His
explorations offer encouragement to see the many aspects of daily
life as practices together in the "arts of living."

Each letter offers readers "secrets" about the inner life of
Vincent van Gogh, who viewed his canvas as a musical instrument
and understood painting as the creation of beautiful music; who,
importantly, attended to the creative imaginings of those around
him; and who always took his imaginings and questions seriously.

Vincent to Theo, Letter 805

Saint-Rémy-de-Provence, September 1889

[on copying Millet's black-and-white *Travaux des champs*
("Labors of the fields") in color]

You'll be surprised what effect the Travaux des champs
[takes] on in colour; it's a very intimate series of his.

What I'm seeking in it, and why it seems good to me
to copy them, I'm going to try to tell you. We painters are
always asked to *compose* ourselves and *to be nothing but
composers*.

Very well—but in music it isn't so—and if such a
person plays some Beethoven he'll add his personal
interpretation to it—in music, and then above all for

singing—a composer's *Interpretation* is something, and it isn't a hard and fast rule that only the composer plays his own compositions.

Good—since I'm above all ill at present, I'm trying to do something to console myself, for my own pleasure.

I place the black-and-white by Delacroix or Millet or after them in front of me as a subject. And then I improvise colour on it but, being me, not completely of course, but seeking memories of *their* paintings—but the memory, the vague consonance of colours that are in the same sentiment, if not right—that's my own interpretation.

Heaps of people don't copy. Heaps of others do copy—for me, I set myself to it by chance, and I find that it teaches and above all sometimes consoles.

So then my brush goes between my fingers as if it were a bow on the violin and absolutely for my pleasure. Today I attempted the Sheep shearer in a colour scale ranging from lilac to yellow.

For Reflection

We must put an artist's work in the context of the artist's life. Vincent was seriously ill in the Saint-Rémy asylum from May of 1889 until May of 1890, yet he continued to paint when physically able. When creating original works was too difficult, he began copying, or "translating," prints of favorite artists such as Millet into his own color palette. He found this activity relaxing and consoling. His wish to collaborate with those he

admired became works of gratitude. It is during this period that he compares his painting to music, and his brush to a violinist's bow. We learn how consoling creative work was for him in the midst of illness, and are invited to share his physical state and his search for healing.

For Creative Engagement

Can you share with other artists their suffering and search for healing through creative work? Can Vincent's means of working out his gratitude to artists he admired strengthen you in times of difficulty and in your creative work? Take time to collaborate—translate, copy—the work of an artist in your own palette. Notice what you learn, what music you hear, what color you discover, how you feel your own body's role in your life work in this act of translation. Vincent discovered consolation in the process, a kind of consolation Oliver Sacks writes about in his final book, *Gratitude*.

The Equivalent of a Good Deed

In the Saint-Rémy asylum, Vincent had great difficulty finding anyone willing and able to pose for a portrait, and so when weather or illness kept him inside, he either had to paint his own portrait over and over or treat as a model the work of some other artist who inspired him. He asked Theo to send him black-and-white prints or photos of works by his personal "saint," the peasant-painter Jean-François Millet. These he would then "translate" into color paintings.

One of Vincent's copies in color from a black-and-white photo of a Millet drawing is the painting now titled *A Child's First Steps*. The painting—in soft blues and greens with white and yellow, as well as a touch of pink, tan, and orange—takes us into the kitchen garden just outside a small thatched-roof peasant cottage. White diapers hang on the fence. A peasant woman stands beside the garden steadying a toddler reaching out toward her father, who has come in from the fields to watch

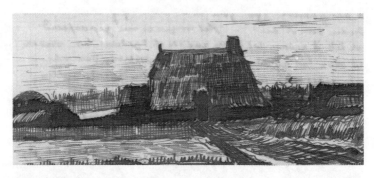

their child try to walk. Millet and Van Gogh both invite us to take notice of and to honor the simplest of family sacraments, in this case a child's first steps.

What was Vincent thinking when he copied this painting? He knew the Millet family had six daughters who were often featured in their father's paintings, and he admired the family focus of Millet's work. Early in his own brief painting career, he had sketched the young daughter and the newborn son of the woman he took into his studio in The Hague. Later, in Arles, he painted all the children in the postman's family, and did several paintings of Augustine Roulin holding her new daughter, Marcelle. For Vincent, the transforming presence of a child was worthy of special attention, to be viewed as a consoling sacrament.

Certainly, his awaiting the birth of his godchild to Theo and Jo was on his mind, and he hoped it would be a successful birth that would transform their lives. Though this was also a period in the asylum when Vincent himself suffered several serious epileptic-like seizures, his time with the image of a child with its parents in a Millet drawing became both a consolation and an inspiration

he wished to share. He would send it to his expectant sister-in-law and his brother as a special gift. Vincent had once spoken of a painting as being "the equivalent of a good deed." And his painting of *A Child's First Steps* functioned as a doubly good deed: he honored Millet's work as created in a peasant-artist's home; and sending the work to Theo and Jo would serve as a way wish them the blessing of a healthy family.

Vincent to Theo, Letter 815

Saint-Rémy-de-Provence, October 20, 1889

Do you know that it might be interesting to try to do Millet's drawings as paintings, that would be a very special collection of copies. . . .

Perhaps I'd be more useful doing that than through my own painting. . . .

Ah, at the moment you yourself are fully in the midst of nature, since you write that Jo already feels her child quicken—it's much more interesting even than landscape, and I'm very pleased that it has changed like this for you.

How beautiful the Millet is, A [sic] child's first steps!

For Reflection

Translating into color the print of a peasant family celebrating their child's first steps was a work of love dedicated by Vincent to the artist Millet and to Johanna and Theo's new child. Vincent had written that "a painting is the equivalent of a good deed" (Letter 853) and immediately sent the painting *A Child's First Steps* to the new parents in honor of this family "sacrament." Are there vivid images in your own memory of such "sacraments" and the sharing of such "good deeds"?

For Creative Engagement

Do you have some treasure box of shared memories and good deeds you can access in quiet moments of reflection? Is there an event in your life or the life of those near you that calls for your turning to a creative form to "sacralize" or honor it? Try today to sort through some such events; test their power to console and heal in times of difficulty or to enrich in moments of celebrating the shared lives of families, communities, and friends.

Revelation in a Newborn Calf, and in the Cypress Tree

Hundreds of books have struggled with the relationship between religion and art. Some have found them to be essentially the same aspect of culture; others have found them to be implacable enemies or competitors for human attention. Is there some meeting place of art and religion we can honestly call "religious art"? If so, is it "religious" by content, by artist's intent, by critic's analysis, or according to the subjective response of viewers?

Vincent's very life-story as evangelist-turned-artist was bound to raise such issues regarding his art and his spiritual journey. An examination of his work reveals that he painted biblical subjects only when he was copying the work of some favorite artist such as Rembrandt or Delacroix. The exception was his two-time attempt to paint his own "Jesus in Gethsemane," both of which experiments he purposely later destroyed (Letters 637 and 685).

Vincent's friends Paul Gauguin and
Émile Bernard, as "Symbolists" focused
on painting ideas through imagination
and "dreaming," often turned to specific
biblical scenes for the subjects of their
paintings. This aspect of his friends'
art led to a strong negative response
by Vincent: he felt they were re-
creating "medieval tapestries" when
their task as modern artists was to
explore, celebrate, and console the
immediate world around them.
For Vincent, spirituality must be
available to modern artists within
the struggles and suffering of
peasants and laborers of their own

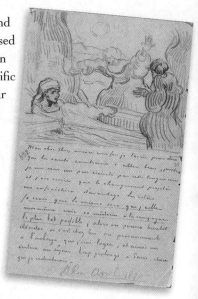

day. Revelation and consolation must be found in a current wheat
field, cypress tree, sunflower, or a child's eyes. If it cannot be found
in one's own time and place, it is most likely inauthentic, a sham
borrowed from history.

When Bernard sent Vincent a set of photographs of his recent
paintings of scenes from the life of Jesus, Vincent wrote back to
him that such work struck him as unhealthy, atrocious, insincere,
a revival of "medieval tapestries." It was an abandoning of their
calling as serious modern artists. Vincent opposed those borrowings
from past imagery through his own effort to find the spiritual in
"what is nearest to us." He wrote to Bernard, "My ambition is
truly limited to a few clods of earth, some sprouting wheat. An

olive grove. A cypress." To make clear his rejection of paintings such as *Jesus in Gethsemane* that both Gauguin and Bernard had painted, he called attention to Millet's painting of a newborn calf carried by peasants from the fields to their cottage. That work, he wrote Bernard, was "so powerful that it makes you tremble." He then described paintings he had just done at the asylum garden as healthy alternatives to their "medieval tapestry" approach to spirituality. Rather than look to over-intended religious imagery, Vincent sought the visual language of the local landscapes and peoples that would provide a consoling art for his own time— an art fostering spirituality and compassion for his generation.

Vincent to Émile Bernard, Letter 822

Arles, November 26, 1889

[Response upon receiving photos of Bernard's paintings on biblical themes]

Look, in the adoration of the shepherds, the landscape charms me too much for me to dare to criticize, and nevertheless it's too great an impossibility to imagine a birth like that, on the very road, the mother who starts praying instead of giving suck, the fat ecclesiastical bigwigs, kneeling as if in an epileptic fit, God knows how or why they're there, but I myself do not find it healthy.

Because I adore the true, the possible, were I ever capable of spiritual fervour; so I bow before that study, so powerful that it makes you tremble, by *père* Millet—peasants

carrying to the farmhouse a calf born in the fields. Now, my friend—people have felt that from France to America. After that, would you go back to renewing medieval tapestries for us? Truly, is this a sincere conviction? NO, you can do better than that. . . .

And when I compare that with that nightmare of a Christ in the Garden of Olives, well, it makes me feel sad, and I herewith ask you again, crying out loud and giving you a piece of my mind with all the power of my lungs, to please become a little more yourself again.

The Christ carrying his Cross is atrocious. Are the splashes of colour in it harmonious? But I won't let you off the hook for a COMMONPLACE—commonplace, you hear—in the composition. . . .

In order to give an impression of anxiety, you can try to do it without heading straight for the historical garden of Gethsemane; in order to offer a consoling and gentle subject it isn't necessary to depict the figures from the Sermon on the Mount—ah—it is—no doubt—wise, right, to be moved by the Bible, but modern reality has such a hold over us that even when trying abstractly to reconstruct ancient times in our thoughts—just at that very moment the petty events of our lives tear us away from these meditations and our own adventures throw us forcibly into personal sensations: joy, boredom, suffering, anger or smiling.

For Reflection

Vincent struggled with the tension between paintings of traditional religious scenes and desire to see a consoling art for his own time. Though he often hung traditional biblical scenes in his studio, his own creations generally focused on the deep meaning to be found in blossoming trees, sprouting wheat, a peasant's face, an olive orchard. When his friend Bernard painted biblical scenes, Vincent responded by describing Millet's painting of peasants carrying a newborn calf home to be cared for. Vincent leaves us with the question, What is the art best suited to foster deep meaning, compassion, sharing, and consolation for us and our generation?

For Creative Engagement

Consider the scenes from life that most move you to meditative attentiveness, stir up your gratitude, console you on difficult days, bring healing when you suffer. Almost certainly there will be diversity of choices when we humans have such different histories. Consider a series of Vincent's paintings that most speak to you. Was his choice of subjects the simplest things in the lives of the people among whom he lived? Was he on a quest to recover the forgotten? Did he hope to convince us to search the darkest corners for things lost or overlooked? Create your own list of such things hidden or lost in our own generation. What discoveries might match Vincent's focus on sunflowers, the cypress tree, the family sacraments, the sun on a puddle, a mother's lullaby to her child?

ILLUMINATION 32

A Source for Consoling Light:
Paying Attention to What You Have It in Your Heart to Do

Often, significant moments and creative ideas so multiply
in Vincent's letters that the reader is drawn into events as
though they were part of a mystery story unfolding. We
seek to learn the outcome of decisions about to be made
and of unanticipated twists and turns to the life of the
correspondents. Consider this beautiful passage as Vincent
imagines a painting he has considered creating for some time,
the painting of an ordinary Paris bookstore at night with
the shadows of passing persons highlighted by its windows,
and its display of books and prints illuminated. Note the
context Vincent has already planned for the painting, with
his paintings of glowing fields of golden wheat and green and
purple olive groves on either side, creating a religious triptych.

As he describes the whole, it will be a source of consoling light, a sowing season of new hope in both word and color for humanity. The painting he imagines will honor the books he loves, perhaps especially the set of Shakespeare's plays he had requested from Theo and is busy reading. But the reference to the bookstore's prints might also reflect his hope to find a less expensive way to get art into the homes of ordinary people.

Those familiar with Van Gogh's body of artwork may realize that no marvelous painting of a bookshop or related triptych exist as a source of much-needed light. The mystery reader asks, What does his future actually hold? At this time Vincent is about halfway through a year in the asylum at Saint-Rémy in Provence. By January he will have his fourth major epileptic-like attack that will stun and confuse him for two full months. In deep depression he will not be able to read or write letters, and only with great difficulty will he attempt a few strange paintings of scenes he remembers from his life in the Netherlands. The long illness will convince him that he must leave the asylum and try to heal himself back in the north.

When he gets to Paris, he is excited to see Theo again and to meet Johanna and his new godchild, another Vincent Willem van Gogh. From there he will travel to the nearby village of Auvers on the Oise River, where he hopes his

return to the north and the local Dr. Gachet might help him recover. But we know that the artist, once he arrives in Auvers, will have only seventy days left to live.

Perhaps even an imagined painting of a bookshop between wheat fields and olive orchards that provides "light in the darkness" should be counted as part of the art heritage of Vincent van Gogh, an imaginary painting in an imaginary museum, revealed to us in the letters. That is one more proof of the special value of the letters his family and friends kept alive. There we can read about even the paintings imagined but not realized on canvas.

The imagined triptych, with a luminous bookstore between olive grove and wheat field, again demonstrates both the deep spiritual content of human creativity through the volumes that contain its stories, and the fertility of earth itself as nurturing home to those stories. Vincent's search for the unity of life hidden in earth's seeds, growth, and gifts, and in the love at the heart of human life, led to one of the artist's deepest discoveries.

Vincent to Theo, Letter 823

Saint-Rémy-de-Provence, November 26, 1889

I keep telling myself that I still have it in my heart to paint a bookshop one day with the shop window yellow-pink, in the evening, and the passers-by black—it's such an essentially modern subject. Because it also appears such a figurative source of light. I say, that would be a subject that would look good between an olive grove and a wheatfield, the

sowing of books, of prints. I have that very much in my heart to do, like a light in the darkness. Yes, there's a way of seeing Paris as beautiful. But anyway, bookshops aren't hares, and there's no hurry, and I have a good will to work here for another year, which will probably be wiser.

For Reflection

Vincent looked forward to leaving the asylum in the south of France to see brother Theo, Johanna, and their new child, Vincent, in Paris. That hope brought with it an imagined scene he hoped to paint: a Paris bookstore with books and prints. He had already planned that it should be placed between a painting of a wheat field and one of an olive orchard to form a sort of spiritual triptych as a source of light in the darkness. Shouldn't this act of hopeful imagination be counted among Vincent's greatest works in some imaginary museum?

For Creative Engagement

Try the difficult exercise of searching your memory for exciting creations, ideas, or relationships that you never got to realize outside your imaginings. Perhaps it was an imagined place to live, a person to befriend, a good deed to be done, work to be accomplished. Does such a creative piece of imagination tell you a good bit about yourself? Has it guided you on meaningful paths? Might it still be realized in some manner? Has it encouraged friends or family as a creative dream? Does it hold some mystery comparable to Robert Frost's "road not taken"?

ILLUMINATION 33

Facing Illness:
The Continuing Power of Art to Support, Console, and Create Empathy

Over the years, many theories have arisen regarding the nature of the illnesses that led to Vincent van Gogh's seizures and resulted in his year in the Saint-Rémy asylum. Many have also looked at the continuing power of his art through it all to support, console, and define him. Were the doctors of his day correct in viewing his illness as a form of epilepsy? Were his seizures brought on by lead or other substances in the paint or turpentine he used? Could it be the effects of overuse of the popular drink of artists of that time in Paris, absinthe? Was there an inherited trait that led both to his illness and to his sister Willemien's many years of silence in an asylum? Did he have bipolar disease, or the ear-related Meniere's disease?

Many volumes have been dedicated to these questions. Yet, despite the serious seizures, nightmares, strange voices he

heard, and periods of dizzying confusion, Vincent continued to create an art that has both inspired and consoled the well and the ill alike.

In Vincent's view, periods of illness did not produce his art, but rather interrupted it and made his plans to create a body of work much more difficult. He would write during the last year of his life, "Ah, if I'd been able to work without this bloody illness! How many things I could have done, isolated from the others, according to what the land would tell me" (Letter 865).

His own illness did, however, make him more sympathetic to and understanding of others who suffered, and he sought ways to accept illness as a discipline and teacher when it could not be avoided. In many of his letters to Theo and others we find him struggling to recover, to communicate again, and to deal with confusion and frightening episodes. In the letters he also expresses his thankfulness for the year he spent in the asylum living among other sufferers, some of whom howled

through the night, smashed furniture, or were unable to communicate, yet also often took an interest in his painting in the asylum garden. Being with them taught him both how difficult life

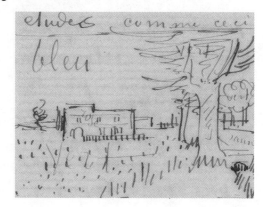

could be for many and what gratitude he owed his opportunity to paint consoling images for a world where so many suffered.

In the following letter, he writes from the asylum to Marie Ginoux, who appears in several of his paintings, and who he feared was seriously ill. She and her husband were managers of the Night Café where he had roomed, the café for the down-and-out that he painted while in Arles.

Vincent to Joseph and Marie Ginoux, Letter 842

Saint-Rémy-de-Provence, January 20, 1890

I myself believe that the annoyances one experiences in the ordinary routine of life do us at least as much good as bad. The thing that makes one fall ill, overcome by discouragement, today, that same thing gives us the energy, once the illness is over, to get up and want to recover the next day.

I can assure you that the other year it almost vexed me to recover my health—to be better for a longer or shorter time—continuing always to fear relapses—almost vexed—I tell you—so little desire did I have to begin again. I've very often told myself that I'd prefer that there be nothing more and that it was over. Well yes—we're not the master of that— of our existence, and it's a matter, seemingly, of learning to want to live on, even when suffering. Ah, I feel so cowardly in that respect, even as my health returns. I still fear. So who am I to encourage others, you'll rightly say to me, it hardly suits me. . . .

Illnesses are there to make us remember again that we aren't made of wood. That's what seems the good side of all this to me. Then afterwards one goes back to one's everyday work less fearful of the annoyances, with a new store of serenity.

For Reflection

Vincent's illness did not create his art, but his art certainly had the power to restore him, see him through grave difficulties, and make him more understanding of the sufferings of others. He wrote to his ill friend, Madame Ginoux, that "afterwards one goes back to one's everyday work less fearful of the annoyances, with a new store of serenity."

For Creative Engagement

You have likely had your share of illness. Are there gifts given by such periods of pain and suffering? Were you led to review direction of your life, your manner of living each day? Does illness remind us of our physical limitations, our sharing in the problems facing all living things? Has healing come, and has it brought a "new store of serenity" and compassion for others who suffer? What has that meant for your creative life?

Engaging Heartfelt Communion

One of the most moving and revealing moments in the Van Gogh correspondence is an exchange between Theo's new wife, Johanna, and Vincent, who has yet to meet her. Johanna sits at her apartment table in Paris at midnight. She is in the pain of early labor, and writes a brief note to Vincent while a worried and exhausted Theo falls asleep. She and Theo must both be thinking of all the things that often went wrong in those days for women in childbirth. The doctor sleeps in another room, expecting Johanna to go into advanced labor at any time. Vincent himself is in his room with bars on the window in the Saint-Rémy asylum, about four hundred miles away, and is just barely recovering from an epileptic-like episode. The exchange of notes tells us something of the bond and understanding between Vincent, Theo, and Johanna. It is that heartfelt communion, about to be joined by the child, to be named after the artist, that will lead to the safekeeping of all

these letters, as well as of Vincent's paintings and drawings.

Below is the heart of Johanna's note to Vincent, followed by Vincent's response two days later. Both letters show a surprising sensitivity: not only in Johanna's sharing with Vincent at such a moment in her life, but in the equally surprising sensitivity of Vincent's response, an empathy— a heartfelt communion—that also formed the generative nature of his creative work.

Johanna to Vincent, Letter 845

Paris, January 29, 1890

It's just midnight—the doctor's sleeping for a while because he wanted to stay here tonight . . . will the baby be here tomorrow morning? I can't write much—but I so wanted to talk to you for a moment. . . .

This evening—all these last few days in fact—I've thought about it so much, whether I really have been able to do something to make Theo happy in his marriage. He's done it for me. He's been so good to me; so good—if things don't go well—if I have to leave him—you tell him—for there's no one in the world whom he loves as much—that he must

never regret that we were married, because he's made me so happy. It sounds sentimental—a message like this—but *I* can't tell him now. . . .

When you get this it will all be over.

Believe me, your loving Jo

Vincent to Johanna, Letter 846

Saint-Rémy-de-Provence, January 31, 1890

Dear Jo,

It touches me so much that you write to me so calmly and so much master of yourself on one of your difficult nights. How I long to hear that you've come through safely and that your child lives. How happy Theo will be, and a new sun will rise in him when he sees you recovering. Forgive me if I tell you that to my mind recovery takes a long time and is no easier than being ill. Our parents know *that* too, and following them in that is, I believe, what one calls duty. Well for my part, I'm thinking about all of you these days. . . .

So much with you and them in thought

Your brother Vincent

For Reflection

Does Johanna's midnight note to her husband's brother move you to affirm her essential role in the story of Vincent's art? Does her love of Theo and compassion for Vincent suffering in his asylum create the atmosphere essential for preserving for us both the art and the healing drama of the Van Gogh family? Does Vincent's reply, with its hope for Johanna's recovery, complete that picture of shared love and concern?

For Creative Engagement

Imagine with me the role of Johanna and her relation to Theo and his brother Vincent. With Vincent's tragic death on July 29 of 1890, and Theo's death within six months, wasn't the likeliest outcome that Johanna would return to Holland with her year-old son, leaving the bulk of Van Gogh's paintings and letters in an abandoned Paris apartment to be destroyed? Does that remind us that there are no small parts in the drama of life? Were Theo's years of supporting Vincent, and Johanna's stewardship of Vincent's art and letters, as essential as Vincent's own painting and writing? Think through your own life and those who have made possible your achievements. Now think through your own role in the lives of those around you. What has been done for you, and how might you contribute to others?

Humble Gratitude and the Gift of Remaining True

George-Albert Aurier, an art critic, writer, and painter, had written the first significant "study" of Vincent van Gogh for the January 1890 issue of *Mercure de France*, an article titled "Les isolès: Vincent van Gogh." Vincent had barely seven months to live when the article appeared and had long struggled to put his work out into the world. Aurier's article would succeed in dramatically widening the scope of Vincent's viewers, critics, friends, and detractors. Vincent's first reaction was to ask Theo to send copies of the article to the art dealers Alexander Reid, H. C. Tersteeg, and his uncle, C. M. van Gogh, all three of whom were positioned to help Vincent in his years of poverty as an artist, but largely ignored or insulted him. Before the article was published, Vincent had endured two months of fear and isolation in his cell at the asylum and had suffered an especially

severe attack of his illness. This had led to his insistence on returning to the north, where he felt healing might be available.

It's difficult to describe Aurier's *Mercure* article. In some ways it provided Van Gogh with someone who was able to articulate his groundbreaking work, indeed his greatness. Vincent himself wrote his thanks to Aurier and declared that "I like it very much as a work of art in itself, I feel that you create colors with your words; anyway I rediscover my canvases in your article, but better than they really are—richer, more significant" (Letter 853). Vincent humbly goes on to note that others better deserve the praise Aurier directs to him, especially Monticelli and Paul Gauguin, among others. In his article, Aurier calls Vincent a "Symbolist" who paints ideas, but also calls him a "realist" who is "good and duly Dutch"; he praises the "naive truthfulness of his art," as well as his "profound and almost childlike sincerity, and great love for nature and for truth."

Reading this, Vincent would likely have crossed out the reference to himself as a "Symbolist" who painted ideas, as well as many of the passages that focused on the "violence" of his painting rather than on what Vincent perceived as "consolation." But perhaps Vincent would have accepted the rest and taken the article as one that understood aspects of his work he had sought to explore through letters. As we read Vincent's letter below, we see that he still struggles regarding his role in the future of art. Should he be a musician of colors, perhaps one of the first true "expressionists," or does his love of the earth and its creatures mean so much to him that he prefers to sit among earth's creatures as a "shoemaker"? That he chooses to be a "shoemaker" suggests his deep love for the ordinary and for those who labor here to

provide for the needs of others. But the music of colors continues to inspire and feed his imagination. Perhaps his several paintings of empty shoes reflect his struggle between shoemaker and musician of colors. Among his paintings of shoes are the clogs of peasants borrowed from the art of his hero Millet, and the city-worker's muddy boots. It is one of his paintings of muddy shoes that inspired the philosopher Martin Heidegger to rethink the very meaning of a "work of art."

Two months after reading the article, Vincent penned a letter to Theo, asking him to "please ask Mr. Aurier not to write any more articles about my painting, tell him earnestly that first he is wrong about me, then that really I feel too damaged by grief to be able to face up to publicity. Making paintings distracts me — but if I hear talk of them that pains me more than he knows" (Letter 863). Vincent saw the challenge to be the artist that Aurier saw in him as one he wasn't sure he could live into. Yet, on some level

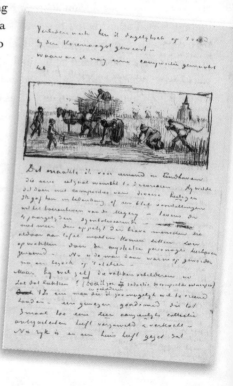

he acknowledged what the article meant, and it inspired him to think even more deeply about his work and his insistence to stay close to the earth, where "shoemaker" was the closest vision that incorporated the clods of earth.

Vincent to Theo, Letter 854

Saint-Rémy-de-Provence, February 12, 1890

Aurier's article would encourage me, if I dared let myself go, to risk emerging from reality more and making a kind of tonal music with colour, as some Monticellis are. But the truth is so dear to me, *trying to create something true* also, anyway I think, I think I still prefer to be a shoemaker than to be a musician, with colours.

In any event, trying to remain true is perhaps a remedy to combat the illness that still continues to worry me.

For Reflection

The art critic Aurier's article celebrating Vincent's art came just seven months before the artist died. Can public praise confuse and perhaps even mislead us regarding the meaning of our work? Vincent gave Aurier's article a serious reading, praised it as a "work of art in itself," but remained true to his own struggle to find his life purpose. Would he become a "musician of color" or a down-to-earth "shoemaker" in love with the truths he found in earth and fields of wheat, in blossoming trees and

the faces of ordinary persons? He leans toward "shoemaker," but leaves the future open. Rather than focusing on himself in his response to Aurier, he praises other artists he feels better deserve Aurier's affirmation.

For Creative Engagement

Can you enjoy the attention others give your life and work and still remain true to the inner voices that help you plot your life journey and its responsibilities? Can you be gracious to those who take notice of your work, yet remain true to the difficult choices you must make? Is praise potentially as misleading and dangerous as negative criticism and misunderstanding? These are the difficult questions that faced Vincent in his last months. Is it his own humility and will to find beauty in the work of others that keep him on a deepening and creative path with no easy answers? How do you respond to praise? Can you take it as seriously as rejection, yet allow an honest humility to center you and give continuing access to your inner vision?

When Work Proceeds, Serenity Comes

You may recall the words of Johanna, Theo's wife, quoted in the introduction to this book. She wrote of the influence of Vincent's letters on her life: "It was he who helped me to accommodate my life in such a way that I can be at peace with myself. Serenity—this was the favorite word of both [Vincent and Theo], the something they considered the highest. Serenity—I have found it."

Our favorite words do reveal much about who we are and what we seek in life. The word *serenity* occurs over fifty times in our collection of Vincent's letters, most often as he explains what he considers necessary for his work and what he feels comes as a result of his work. It is also the gift he wishes for those he loves and admires, including Theo and Jo, his mother, his sister Willemien, and the artist Gauguin. Indeed he writes, "May serenity prevail for all of us" (Letter 234).

But Vincent does not take serenity for granted. He believes he shares with Willemien a "nervous nature" and a tendency

toward "melancholy." His hope is that his work and her interests in the world will bring them both serenity if they are patient. For himself, he finds that serenity comes through work, especially working in nature, and in fact he writes that

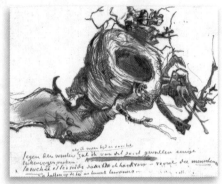

serenity dwells even "in the majesty of certain trees" or in the heath. He relates serenity to calmness, good spirits, cheerfulness, peace, courage, a good heart, and infinite patience, wisdom, and service. He writes that serenity both consoles and inspires, and his deepest wish for Theo and Johanna's marriage is that they will find "much inner serenity."

Vincent to Theo and Jo, Letter 874

Auvers-sur-Oise, May 21, 1890

My dear fellow, upon reflection I don't say that my work is good, but it's the least bad I can do. All the rest, relations with people, is very secondary, because I have no talent for that.

I can't do anything about that.

Not working or working less would cost double, that's all I can foresee IF we sought another way of arriving than the natural way, working—which we shan't do.

Look, if I work, the people who are here will come just as well to my place without my deliberately going to see them as if I took steps to make acquaintances. It's by working that people meet each other, and that's the best way. Am moreover quite convinced that that's your opinion and also Jo's. I can do nothing about my illness—I'm suffering a little these days—it's just that after this long seclusion the days seem like weeks to me.

I had that in Paris, and here too. But as work is proceeding a little, serenity will come.

For Reflection

Have you ever made a study of your own speech, its unique aspects, your favorite words, whether spoken silently to yourself or to others? This might offer an important path to self-understanding. As we may be unaware of our favorite speaking patterns and words, asking friends to reflect that back to us might be useful. We could inquire, "Are there specific words and phrases you associate with me? What do they tell you about me?" Certainly, help in self-understanding is an important factor in identifying our inner world, including our creativity and our chosen work in the world.

For Creative Engagement

Consider asking close friends what words they associate with you and your manner of living life, your spiritual life, your creative life. But also take time to analyze your own language use. Try writing key words you recall using today, this week, or this season. Were they recent borrowings or are they deep in your inner self? Consider Vincent's word *serenity*. Is serenity important to your own journey? Does your work open the door to serenity for you? Does your serenity affect those around you, releasing their creativity and best qualities? Consider making it a goal for serenity to issue from your lifework, in good times and bad.

On Consolations:
Painting Is Something in Itself

Vincent's final letters to his mother and his youngest sister, Willemien, were written on June 13, a little over a month before he shot himself in a field on the hillside above the village of Auvers. Sharing remembrances of the past with his mother, his letter cites poignant, mysterious words they both knew well from the Bible. Drawing on the apostle Paul's first letter to the Corinthian Christians, Vincent mentions seeing "through a glass, darkly" (1 Cor 13:12 KJV). These words follow one of Paul's most quoted poems, which concludes with the primacy of love in spite of the clouded mirror: "Now remain faith, hope, love, these three, and the greatest of these is love" (v. 13). Vincent likely found special consolation that the apostle Paul, who wrote about the primacy of love, also wrote about seeing "through a glass, darkly," sharing Vincent's own uncertainties regarding the present and future, yet holding to the solace of the promise of love. Perhaps this also informed one of his letters to Willemien regarding her essay on the parallels of plant and human life,

which Vincent suggested amending by adding to the essay, "What the power to germinate is in wheat, so love is in us" (Letter 574).

Now, thinking of the love he and his mother shared for Theo, Jo, and their five-month-old child, Vincent went on to write, "I read somewhere that writing a book or making a painting was the same as having a child. I don't dare claim that for myself, though; I've always thought the latter was the most natural and best thing—only *if* it were so and *if* it were the same." Vincent had just undergone the trauma of epileptic-like attacks and a year's stay in an asylum. The birth of his godson to his brother and sister-in-law might have given him comfort and the promise of a brighter future in an unsettling world. Yet, his concern for that child and his parents, with their limited resources and fragile health, and his concern that another seizure might be near for him revealed a more uncertain future.

In an earlier set of letters Vincent had mentioned painting his father's Bible open to the prophet Isaiah's account of a "suffering servant," one who gave his life for others. Certainly, that example of loving sacrifice was not lost on the evangelist-artist. As he wrote this letter to his mother, he would have been mindful that Theo's art dealings had just made possible the posthumous sale of a painting by Jean-Baptiste-Camille Corot (1796–1875) at a 5,000-franc

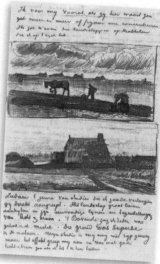

profit for Theo's employers. Would Vincent have wondered if his own work, those hundreds of paintings rolled up in Theo's apartment, suddenly could become a treasure rather than a loss for Theo and his family if the artist were dead? While scholars question the circumstances and motivations behind the shot to Vincent's stomach and whether it was self-inflicted or not, his own letter maintains that despite seeing "through a glass, darkly," his intention—the ultimate good, the ultimate path, the ultimate motivation for him—was always love.

Vincent to his widowed mother, Letter 885

Auvers-sur-Oise, June 13, 1890

It struck me in your letter that you said that seeing things again in Nuenen you 'were grateful that it had once been yours'—and were now content to leave everything to the others.

Through a glass, darkly—it has remained thus; life and the why of parting and passing away and the persistence of turmoil, one understands no more of it than that.

For me life might well remain solitary. I haven't perceived those to whom I've been most attached other than through a glass, darkly.

And yet there's a reason why there's sometimes more harmony in my work nowadays. Painting is something in itself. Last year I read somewhere that writing a book or making a painting was the same as having a child. I don't dare claim that for myself, though; I've always thought the latter was the most natural and best thing—only *if* it were so and *if* it were the same.

For Reflection

Vincent has only forty-six days to live when he writes this letter to his mother. There is a sense of peace and gratitude in his musings on her life and his. He writes that "there's sometimes more harmony in my work nowadays," and indicates that the harmony comes from painting itself and its relationship to "having a child." Likely he is thinking of his mother's joy in becoming a grandmother to Theo and Johanna's son, and he indicates that their having a child is "the most natural and best thing." Vincent humbly puts the accomplishment of Theo and Johanna above his work as painter, but does suggest that his painting at its best suggests birthing a new life. Do Vincent's musings here illuminate the nature of creative work as a kind of life-giving process?

For Creative Engagement

Consider the tone of quiet sharing and the recognition of the deeper mystery of art and life this letter reveals. Do we too seldom communicate with others on this level? Do you have a sense that the consolation of painting is a gift received by Vincent in return for his ten-year journey of creative discovery? Consider your own work. Are you on such a journey? Are you willing to persist in this journey? Do you perceive something being born, or born out of the journey?

ILLUMINATION 38

Discovering Something Like Waiting and a Shout

Vincent's last letter to sister Willemien largely consists of descriptions of paintings he recently completed. "I've been working a lot and quickly," he writes; "by doing so I'm trying to express the desperately swift passage of things in modern life." His very pace of painting and, no doubt, the choices of subject and form serve as a portrait-in-time of Vincent and, themselves, form his message for his sister in the rush of here and now, to complete a mission of consolation.

The first painting he describes is "a large landscape viewed from a height in which there are fields as far as the eye can see." Included in the broad scene are reaper and wheat, potato plants, and more, forming a collection in the current painting of meaningful themes from his earlier works. He describes within this painting a train pulled by a locomotive leaving a trail of smoke, which is evocative of an earlier letter to Theo, in

which Vincent
linked apparent
opposites to
describe the
infinite: "And
a baby in its
cradle . . . has the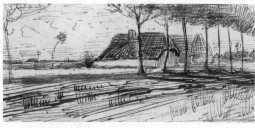
infinite in its eyes," while on a journey by train "you go fast, but you
can't distinguish any object very close up, and above all, you can't
see the locomotive" (Letter 656).

Among the other paintings he describes for Willemien is a
portrait of Dr. Gachet, the doctor in Auvers whose promise of
help led Vincent from the asylum to the country village close to
Paris and Theo's family. Alongside the reflection on the infinite
nature of the locomotive, Vincent's description of the melancholy
portrait of Gachet brings together the promise, yet vulnerability,
of his godchild: the infinite in a baby's eyes, the confusing speed
and smoke of a locomotive. In the presence of Dr. Gachet he sees
a form of the wounded healer he hopes will dispense consolation
for him. In a letter to Gauguin, Vincent indeed makes the
comparison of his portrait of Dr. Gachet to Gauguin's portrait
of another wounded healer, "Christ in the Garden of Olives."
(Related Manuscript 23). Was it that looking for the infinite in
the disparate images that allowed Vincent to point to that which
was seemingly an incomprehensible good—that what is wounded
might offer healing?

Vincent to Willemien, Letter 886

Auvers-sur-Oise, June 13, 1890

Yesterday in the rain I painted a large landscape viewed from a height in which there are fields as far as the eye can see, different kinds of greenery, a dark green field of potatoes, between the regular plants the lush, violet earth a field of peas in flower whitening to the side, a field of pink-flowered lucerne with a small figure of a reaper, a field of long, ripe grass, fawn in hue, then wheatfields, poplars, a last line of blue hills on the horizon, at the bottom of which a train is passing, leaving behind it an immense trail of white smoke in the greenery. . . .

I've done the portrait of Mr. Gachet with an expression of melancholy which might often appear to be a grimace to those looking at the canvas. And yet that's what should be painted, because then one can realize, compared to the calm ancient portraits, how much expression there is in our present-day heads, and passion and something like waiting and a shout. Sad but gentle but clear and intelligent, that's how many portraits should be done, that would still have a certain effect on people at times.

For Reflection

Vincent's last letter to his youngest sister, Willemien, gives a sense of finality and a rush to complete his vision of the landscape with its relationship to the human search for meaning. He writes, "I've been working a lot and quickly," and adds that he seeks to express "the desperately swift passage of things in modern life." The painting he describes for her includes wheat, potato plants, a reaper, and a locomotive. Is this his last attempt to tie together the fertility of earth, the work of the peasant, and the confusion of a new technology of speed and power? To this work he adds his painting of Dr. Gachet, "sad but gentle but clear and intelligent." Is this his hope for clear-minded healers in our world's time of need?

For Creative Engagement

Take some time to examine your own life today. As you do, pull together its many strands of meaning. Does the pattern of these strands reveal itself in a manner that allows you to "paint" your most creative future possibilities? Begin with just the day ahead. Can you be one of the "clear and intelligent" healers for those you meet today?

ILLUMINATION 39

The Importance of Working in the Garden

Vincent had already written what
appeared to be a "last letter"
specifically to his mother and a "last
letter" specifically to Willemien,
both placed in the same envelope,
on June 13, 1890. But now he
addresses mother and sister
together, a month later, in a thank-
you note for letters they had sent
him, and to reassure them of his
calmer mood. He praises Willemien
and the doctors at her new hospital
job who "endeavour to do what
has to be done simply and sensibly
and with kindness." He adds,
probably quoting the lost letter

from his sister, "But precisely for one's health, as you say—it's very necessary to work in the garden and to see the flowers growing."

Finally, his note adds a beautiful passage describing how he is "wholly absorbed in the vast expanse of wheatfields against the hills, large as a sea." He includes careful details as to the variety and color of the landscape, and ends by wishing that mother and sister enjoy their days with Theo, Jo, and their new baby.

Vincent's focus on the details of what he sees—delicate yellow wheat fields, purple plowed land, flowering potato plants, and a blue, white, pink, and violet sky—seems to sum up aspects of earth and heaven that he found beautiful from the beginning of his life to the end. Simply to list what he sees is a spiritual litany he wishes to leave with these two people he loves. That he praises his sister's hospital work, and quotes her words that it's "very necessary to work in the garden and to see the flowers growing," could easily be the epitaph he would approve for them and for himself.

Vincent to his mother and Willemien, Letter 899

Auvers-sur-Oise, July 14, 1890

But precisely for one's health, as you say—it's very necessary to work in the garden and to see the flowers growing.

For my part, I'm wholly absorbed in the vast expanse of wheatfields against the hills, large as a sea, delicate yellow, delicate pale green, delicate purple of a ploughed and weeded piece of land, regularly speckled with the green of

flowering potato plants, all under a sky with delicate blue, white, pink, violet tones.

I'm wholly in a mood of almost too much calm, in a mood to paint that.

For Reflection

A note of thanks for letters received and of a vision of nature's beauty takes us deep into the soul of the artist. Vincent weaves together thankfulness for family and for the forms and colors of the earth and sky, clearly describing what it means to be absorbed in this very particular moment in life. Read carefully the description of fields, colors of earth, growing things, and the blue, white, pink, and violet tones of the sky, and you will likely realize how much you miss when you are too distracted to be absorbed in life. Here we have Vincent's own epitaph for a life of gratitude lived in nature and dedicated to works he intended to leave behind as "good deeds" for those in need of compassion. What would your gratitude be, your life-engaged epitaph rather than a life-distracted one?

For Creative Engagement

Make a promise to yourself that you'll see your life setting today with the loving care of the artist, describing the breadth and depth of things, the variety of textures and colors. Try putting into a letter, a sketch, or a poem what you have seen, and share the vision with someone who may need such a revelation. Then try returning to your own garden to see what flowers are growing there.

The Artist's Task: How to See, and How to Frame for Others What We See

Vincent's final letter was to brother Theo, written just four days before the artist shot himself in the stomach in the field above Auvers, on July 27, 1890, at age thirty-seven. Two days later, while smoking his pipe and remembering the past with Theo, who was at his bedside, Vincent died in the rented attic room of the Ravoux inn of Auvers-sur-Oise. On July 30, he was buried in the Auvers cemetery, with several artists from Paris present at the funeral.

In keeping with his other letters, Vincent's final words of his last letter to Theo simply described a recent Auvers painting he had made for his brother, of the garden at the Auvers home of Daubigny, an artist known for his landscape paintings. Daubigny was a favorite of Vincent, mentioned in over fifty of his letters. Daubigny's images of nature moved Vincent deeply. Honoring this deceased artist, who had also

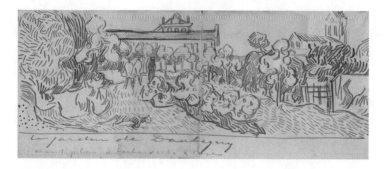

focused on nature, Vincent described his painting of Daubigny's garden in Auvers to comfort and inspire Theo, who was burdened and very ill.

Vincent describes the garden's lilac bushes, plants, and flowers; the house in the background; and "a dark figure with a yellow hat," likely the widow of Daubigny, and "in the foreground a black cat. Sky pale green." To the end Vincent remained the singular artist fascinated by the creative labor of humans and their need for a nearby landscape or personal garden. His description was a sort of parable on how to see, how to frame for others what we see, and how such scenes are right in front of us if we are attentive. He names the garden and its plants and trees, and carefully identifies the colors he used. Elsewhere he told us that such paintings were for our "consolation."

In a way, Vincent's careful descriptions of crops growing in fields where peasants labor, or of flowering plants blooming in the gardens we care for, serve as a "spiritual text" offered by the artist to encourage us to see the world in its details with attentive and thankful eyes. Perhaps as Van Gogh looked to the contemporary

voices of his time to speak to a generation's spiritual and social questions, had he lived in our day he might have sought out Alice Walker's novel *The Color Purple* as a divine gift in that same tradition. Van Gogh held a special love for purple (and its various colorations, like lilac), which is mentioned in almost fifty of his letters. He describes as "purple" the plowed fields, iris, foxglove blossoms, lilacs, cabbages, mists, shadows, tree trunks, the evening sky, and more.

That Vincent's final description is focused on a garden might also direct us to one of his favorite books, Voltaire's *Candide*. That "dark comedy" of a young man driven from home to wander a world filled with grotesque forms of suffering likely suggested to Vincent the tale of his own loss of home, his sufferings, and his search for meaning. Vincent several times cites in his letters the words Voltaire places in the mouth of a naive philosopher in the story, Pangloss, who presumes to teach Candide that this is, after all, "the best of all possible worlds." But in the story's concluding scene, Candide refuses further philosophic talk about "best possible worlds" and insists it is time to act, for "we must cultivate our own garden." Vincent certainly recognized the irony of the story and the rejection of the false optimism of the philosopher as intended by Voltaire. But here it seems the artist wraps that irony and rejection in a deeper discovery—that ordinary peasants and laborers have discovered in their own "gardens" the power of transformation for all forms of life that move from seed to harvest to a new seeding. That power in us, Vincent had both written and painted, is love, the infinite made visible in the wheat field, in the blossoming tree, in the eyes of a peasant's newborn calf, or in a newborn child.

Vincent to Theo, Letter 902

Auvers-sur-Oise, July 23, 1890

I'd perhaps like to write to you about many things, but first the desire has passed to such a degree, then I sense the pointlessness of it. . . .

As for myself, I'm applying myself to my canvases with all my attention, I'm trying to do as well as certain painters whom I've liked and admired a great deal. . . .

Daubigny's garden

Foreground of green and pink grass, on the left a green and lilac bush and a stem of plants with whitish foliage. In the middle a bed of roses. To the right a hurdle, a wall, and above the wall a hazel tree with violet foliage.

Then a hedge of lilac, a row of rounded yellow lime trees. The house itself in the background, pink with a roof of bluish tiles. A bench and 3 chairs, a dark figure with a yellow hat, and in the foreground a black cat. Sky pale green.

For Reflection

Vincent's last letter to Theo was written on July 23, just six days before his death on July 29. The letter describes in detail a painting he completed of the deceased artist Daubigny's garden. Framing the scene in words, Vincent leaves with Theo his manner of seeing one chosen piece of earth where flowers, trees, and hedges of lilac lead one to a home. His letter leaves his brother with the vision of earth and human working together to create a garden.

For Creative Engagement

What scene would you like to share with those you love, as a frame for your vision of the world? Might it be the "garden" you created during your lifetime? Such gardens do not grow in a day. Is there some sense that you are, day by day, planting and caring for a vision of earth and humanity in cooperative germination? You might recall Vincent's telling his sister Willemien that what germination is to wheat, love is to humanity. Does that help you consider your own creative task on earth?

In Praise of Acting with Humanity

Scholars have designated loose manuscript pages that could not be placed with certainty with a numbered letter as "Related Manuscripts" (RM); these are placed after the collection of 902 letters in vangoghletters.org. The last two of the twenty-five such documents are by Vincent, designated as RM24 and RM25.

These unsent letters offer an intimate picture of the nature of the artist's life and thought—and add to our understanding of this "second gift" of Vincent van Gogh. These two final letters—one, torn up by the artist and reassembled after his death, and the other, in his pocket when he shot himself—provide insight into Vincent's own understanding, as well as documentation of the transpiring events.

RM24 was apparently written by Vincent in great anxiety after receiving a July 1 letter from Theo, just twenty miles away in Paris. Theo reported (Letter 894) that he and Jo had been "going through the greatest anxiety," as their five-month-old

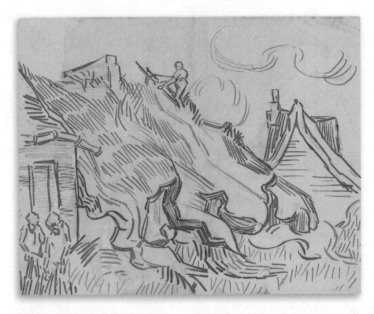

had been crying day and night, and they had feared they would lose him. The child was now improving, but Theo's worries multiplied: Should they find a more convenient apartment for taking care of a baby? Did his job pay too little to properly care for his family? He concluded, "We'll battle all our lives without taking the oats of charity they give to old horses in grand houses. We'll pull the plough until it moves no longer." Theo's emotional letter then tells Vincent that while "you have found your path, old brother, your carriage is already sturdy and strong," Theo views his only hope to be in his wife and child, and in the possibility that his child, "if he may live . . . may be someone."

Vincent, having recently experienced serious seizures and nightmares and now newly released from the asylum, was no doubt shaken deeply by Theo's letter, his false view of Vincent's own health, and his anxiety concerning his wife, their baby, and their future. After reading the letter, Vincent made a day visit to Paris to see Theo, but although the child was better, the parents were worn out by the events. Jo's brother and sister-in-law were present, and there were arguments among them regarding family issues, money, and Theo's uncertain future at the art company. For an emotionally fragile Vincent, this all seemed too much. On seeing the state of things in the Paris household, he returned almost immediately to Auvers.

Vincent's intended response to this confusion, in RM24 on July 7, displays his own anxiety for the child and his worry that he himself has done something to harm Theo and his family: "have I done something wrong, or anyway can I do something or other that you would like?" But Vincent apparently tore up that letter, for around the same time he received a letter he describes as being "like a gospel for me" from Johanna. The letter from Johanna has been lost, but Vincent replaced the torn-up letter with another one, Letter 898, written July 10, expressing his relief. He wrote, "I feared . . . that I was a danger to you, living at your expense — but Jo's letter clearly proves to me that you really feel that for my part I am working and suffering like you." He then turns again to describing new canvases he is painting that "express sadness, extreme loneliness," yet also indicate what is "healthy and fortifying about the countryside." He adds, "I often think of the little one, I believe that certainly it's better to bring up children than to expend all one's nervous energy in making paintings."

The last of the Related Manuscripts is a stained letter, never mailed, and found in Vincent's pocket after his death. It was likely an earlier, incomplete version of one he did mail to Theo, Letter 902. Nevertheless, a few sentences in that stained letter are worth recording, related to Vincent's thoughts about his paintings at a "moment of relative crisis" and Theo's "part in the very production of certain canvases." It's possible to read into Vincent's words here a final defense of his paintings and of the work of living artists, as compared to the great amount of money Theo had just spent securing for his employers a painting by a dead artist, Corot. Perhaps Vincent referred to this to encourage Theo to continue his role as a new sort of art dealer, one who values and represents struggling artists of his own time, in contrast to the exaggerated prices paid by dealers and wealthy art patrons for the work of artists of the past. Even as he reflected on this, there was a sense of returning to one thing that was a constant for Vincent, his art: "Ah well," he writes as though on behalf of himself and other artists equally driven by the work, "really we can only make our paintings speak."

Vincent to Theo, Related Manuscript 25

Auvers-sur-Oise, July 23, 1890

The other painters, whatever they think about it, instinctively keep their distance from discussions on current trade. Ah well, really we can only make our paintings speak.

But however, my dear brother, there's this that I've always told you, and I tell you again once more with all the gravity that can be imparted by the efforts of thought assiduously fixed on trying to do as well as one can—I tell you again that I'll always consider that you're something other than a simple dealer in Corots, that through my intermediacy you have your part in the very production of certain canvases, which even in calamity retain their calm. For that's where we are, and that's all, or at least the main thing I can have to tell you in a moment of relative crisis. In a moment when things are very tense between dealers in paintings—by dead artists—and living artists.

Ah well, I risk my life for my own work and my reason has half foundered in it—very well—but you're not one of the dealers in men; as far as I know and can judge I think you really act with humanity, but what can you do[.]

For Reflection

A torn-up letter and a stained one are among the Related Manuscripts in the Van Gogh collection. Are they final puzzles to be solved? Vincent wrote one in great anxiety after he received a letter from Theo stating that he and Jo feared they would lose their ill child. Vincent wrote the other when the immediate crisis was over, thanking Theo and Jo for their kindnesses. He praised Theo's work supporting living artists. For himself and other artists he stated, "We can only make our

paintings speak." These bits of letters remind us that what we will leave behind will likely include bits and pieces reflecting moments of life's unfinished business. Consider some of those bits and pieces of your creative work. Can you follow a thread of gratitude and serenity shining through?

For Creative Engagement

In Viktor Frankl's book *Man's Search for Meaning*, he asks us to imagine ourselves at the end of our lives looking back in search of the most meaningful moments. This creative practice allows us to live more fully by also intentionally creating just such moments in the days ahead of us. Have the creative moments we have looked at in Vincent's letters stirred thoughts of those intentionally attentive moments in his musings? Recall key themes of gratitude, serenity, and creative engagement with nature and our fellow creatures emerging in his words and inspiring our own experiment in living. Turn again to his artwork, his sketches, now with a new sense of how he intended them to "speak" to us, colored by his own compassion and wisdom, suffering and struggles.

A Brief Afterword

I hope this book has offered a sense of the intimacy and power of Vincent's personal letters — and so also reveals the heartfelt depths and mystery of his words and paintings. But I realize these same letters expose the problems caused by gaps left in half-correspondences and those missing pieces, which don't adequately provide context for understanding.

Are the letters of Van Gogh an effective way to reconstruct the artist's creative life, his search for meaning, and his contribution to the arts and spirituality? As we noted at the outset, our selection of letters and themes has been an intentionally limited one, but my hope is that they provided selections that offer a bridge to the entire correspondence, which again can be found at vangoghletters.org. Perhaps the letters also help us appreciate the challenges faced by biographers of Van Gogh — or the issues we all face in reconstructing and understanding the inner lives of those who have influenced us or offered us way-markers on our own journey.

I hope in this book you have discovered illuminating moments such as, for example, when Vincent urges young Theo to "find things beautiful as much as you can," or shares his excitement in reading *Uncle Tom's Cabin; or Life among the Lowly*. Perhaps you discovered a new breadth to the artist in his special request that Theo send him the plays of Shakespeare for reading in the asylum, or when he reports engaging the landscape of the coalminers to better understand his parishioners. Perhaps you discovered

new complexities to Vincent's spirituality and his search for the infinite, or realized how important it was to him that struggling human beings find consolation in his paintings—or discover the mysteries of the world around us that provide depth and challenge us to act in love.

As I reread Vincent's letters for this book, I discovered a new appreciation for the life-changing trauma and suffering involved in his epileptic-like seizures. His efforts to mute such difficulties to ease Theo's worries were likewise clarified for me, while the change in his understanding of himself became even more evident to me. I also rediscovered the "incarnational" aspect of both his art and his spirituality. For Vincent, art and religion had a strong bodily element connected to his feeling for the earth, germination, and compassion for all creatures and their offspring, notable in his attention to the eyes of an overworked wagon horse or a newborn child. The feel of his canvas and his stroke with the brush compared to the movement of a violin bow impressed me more than ever. Who would have guessed that he could think of his brush as a bow on violin strings if he had not written it himself in that letter? The depth and breadth of his reading as a silent and slow meditative practice within a too-hectic society also emerged for me in new ways: a precursor to today's attempts to seek mindfulness and find new meaning in meditation, walking, gardening, and intentional reading practices.

Among Vincent's last letters, the humility in his words to the art critic Albert Aurier, where he praises Monticelli's paintings and the work of Gauguin as far more important than his own, and his affirming to Aurier that "a good painting should be the equivalent

of a good deed" (Letter 853), remain in my memory. And that earlier exchange of notes between Theo's wife, Johanna, the very night she would deliver a child, and Vincent, still suffering in the asylum from a severe seizure, is as vivid and dramatic as in my first reading. How did Vincent know to tell Johanna that her own health and recovery would be of first importance to brother Theo, whatever the outcome of the birth? He wrote, "How happy Theo will be, and a new sun will rise in him when he sees you recovering. Forgive me if I tell you that to my mind recovery takes a long time and is no easier than being ill" (Letter 846). Another personal discovery in my rereading of Vincent's letters, particularly the last ones to his mother, Theo, and sister Willemien, is the spiritual depth hidden in the simple description of a landscape, a field, or a garden. The loving description of series of plants, trees, crops, flowerbeds became for the artist, I believe, a shared sacrament, a sort of litany to the earth and its healing forms and colors, offered to the persons he loved.

Finally, I simply admit to the fact that I am constantly thinking of passages in letters I did not include in this little volume. I believe that your reading of the full collection of letters might easily suggest to you an entirely different selection of illuminating texts. That indicates to me the richness of the attentiveness of Van Gogh as artist to his own rather brief life and the corners of nature and society he discovered. I hope his discoveries provide both illuminations and consolations for us as we search out creative ways of facing suffering and confusion while living more deeply and compassionately on a planet in crisis that seriously needs our attention, our ability to *see,* and our help.

Acknowledgments

My deep gratitude to Marcia Powell, who, to the very year of her death in 2009, supported my work on Van Gogh. And a special thanks to the Powell-Edwards Fund at Virginia Commonwealth University for supporting the permissions for text and images from the collection of the Van Gogh Museum in the Netherlands.

Another round of gratitude to Lil Copan, editor at Broadleaf Books, who had the dream for this book before I did and helped me at various key stages in bringing this book to print. Grateful thanks as well to Rachel Reyes and James Kegley, who went above and beyond to ensure every detail was right. And thank you to the team at Broadleaf Books, whose enthusiasm for this work has provided necessary energy for my ongoing work and this book's finding its way to readers.

Notes.

Introduction

As the Introduction to this work explains, our key source for the Van Gogh letters is now available on the internet at vangoghletters.org, including the complete text of Vincent van Gogh's available correspondence. The letters are numbered in chronological order, and we use those assigned numbers to locate the letter-source for each of the passages by Van Gogh that serve as the focus of this work. The electronic version provides facsimiles of the letters, a new English translation, letters in their original languages, and images of all available artworks mentioned. There are also scholarly notes, and a search engine to locate key words throughout the letters. Many libraries also have the printed work that lies behind the internet version, *Vincent van Gogh: The Letters*, ed. Leo Jansen, Hans Luijten, and Nienke Bakker, 6 vols. (New York: Thames and Hudson, 2009). In the sixth volume one finds helpful essays on letter writing in Van Gogh's day, the use of letters within his family, notes on the correspondents, maps of the places he visited, and other contextual aids.

For general reference to Vincent's work, see the catalogue to the "Van Gogh's Van Goghs" exhibitions in *Van Gogh's Van Goghs: Masterpieces from the Van Gogh Museum* by Richard Kendall, with contributions by John Leighton and Sjaar van Heugten (Washington, DC: National Gallery of Art, 1998).

For the reference to Picasso and his view of the critical role in art history of Van Gogh, see Susan Alyson Stein, ed., *Van Gogh: A Retrospective* (New York: Hugh Lauter Levin, 1986). The Stein volume is filled with useful biographical material, reviews, letters, and images on the life and times of Van Gogh.

There are numerous studies of the literary aspects of the Bible, including works specifically on the apostle Paul's letters, their structure, and their message. See, for example, Wayne Meeks, ed., *The Writings of St. Paul: A Norton Critical Edition* (New York: Norton, 1972); and the setting provided in Wayne Meeks, *The First Urban Christians: The Social World of the Apostle Paul* (New Haven: Yale University Press, 1983). Thoughtful explorations of the literary qualities of Van Gogh's letters can be found in Patrick Grant's books on Van Gogh. See, for example, *The Letters of Vincent van Gogh: A Critical Study* (Edmonton, Canada: AU Press, 2014).

For more background on letter-writing in Vincent's day and on the use and sharing of letters in the Van Gogh family, see Volume 6, "Background and History," of *Vincent van Gogh: The Letters: The Complete Illustrated and Annotated Edition* (Volumes 1–6), Bakker, Jansen, Luijten (eds.), 2009; as well as "Biographical & Historical Context: The Letter-Writing Culture and Van Gogh's Position within It" and related topics at the Van Gogh Museum's site, vangoghletters.org.

This earlier translation with Johanna van Gogh-Bonger's introduction is *The Complete Letters of Vincent van Gogh*, 3 vols. (New York: Little, Brown, in conjunction with the New York Graphic Society, 1958).

Illumination 1

This list of artists includes several of Vincent's favorites among The Hague School. See, for example, Ronald de Leeuw, John Sillevis, and Charles Dumas, eds., *The Hague School: Dutch Masters of the 19th Century* (London: Royal Academy of Arts, 1983).

Illumination 3

For some discussion of the background of Dutch Protestantism and the theology of Van Gogh's family, see the sources in Kathleen Powers Erickson, *At Eternity's Gate: The Spiritual Vision of Vincent van Gogh* (Grand Rapids: Eerdmans, 1998).

Illumination 4

For background on Harriet Beecher Stowe and *Uncle Tom's Cabin*, see John R. Adams, *Harriet Beecher Stowe*, updated ed. (Boston: Twayne, 1989); and Barbara Hochman, *Uncle Tom's Cabin and the Reading Revolution* (Amherst: University of Massachusetts Press, 2011); Eric Sundquist, ed., *New Essays on Uncle Tom's Cabin* (Cambridge: Cambridge University Press, 1986). In addition, see Harriet Beecher Stowe to Gamaliel Bailey, Brunswick, Maine, March 9, 1851; Boston Public Library, http://utc.iath.virginia.edu/uncletom/utlthbsht.html.

Illumination 5

For a literary perspective and aspects of the breadth and nature of Van Gogh's reading, see Judy Sund, *True to Temperament: Van Gogh and French Naturalist*

Literature (Cambridge: Cambridge University Press, 1992), and Wouter van der Veen, *Van Gogh: A Literary Mind — Literature in the Correspondence of Vincent van Gogh*, Van Gogh Studies 2 (Zwolle: Waanders; Amsterdam: Van Gogh Museum, 2009).

Illumination 6

See the volume *Anthon van Rappard, Companion and Correspondent of Vincent van Gogh: His Life and All His Works* (Amsterdam: Arbeiderspers, 1974).

Regarding quoted words or phrases in this Illumination and throughout the book, these are often taken from within the larger correspondence or from sources related to Vincent's reading and sphere. While each is not sourced, bringing in Vincent's own descriptive words helps give readers clues to how he viewed others or offered a particular insightful or characteristic turn of phrase.

Illumination 8

For Van Gogh's uncle, the artist Anton Mauve (1838–1888), see Leeuw, *The Hague School: Dutch Masters of the 19th Century*, 233–53 and almost a hundred other references. Numerous works by Mauve suggest themes later painted by Vincent van Gogh.

Illumination 10

There are numerous editions and translations of Elisabeth Huberta du Quesne-van Gogh's small book of recollections regarding her older brother Vincent. See, for example, the 2015 edition, *Personal Recollections of Vincent van Gogh* by Andersite Press. See also the selection from her book included in Stein, *Van Gogh: A Retrospective*, 31–32.

Illumination 13

See the several excellent essays on *The Potato Eaters* painting in the Van Gogh Museum publication edited by Louis van Tilborgh, *The Potato Eaters by Vincent van Gogh* (Zwolle: Uitgevers Waanders, 1993).

Illumination 14

See my more complete discussion of the issues involving the painting by Van Gogh of his father's Bible in Cliff Edwards, "From Book to Books," *Van Gogh and God: A Creative Spiritual Quest* (Chicago: Loyola University Press, 1989).

Illumination 17

See my chapter on Van Gogh's "Oriental Connection" in Edwards, *Van Gogh and God*, 85–116. There I make an examination of the sources of Van Gogh's knowledge of Japanese art and possible Buddhist themes and philosophy. Vincent and Theo's collection of Japanese prints is shown and discussed in the *Catalogue of the Van Gogh Museum's Collection of Japanese Prints* (Zwolle: Waanders, 1991). Several useful essays are there as well, including an "Introduction on Van Gogh's Utopian Japonisme" by the Japanese scholar Tsukasa Kodera.

Illumination 19

For my evidence of Theo van Gogh's atheism or agnosticism, see *Brief Happiness: The Correspondence of Theo Van Gogh and Jo Bonger* (Zwolle: Waanders, 1999). Note especially issues regarding a "refusal" of a church wedding. On Vincent's own deep spirituality and musings, see Kenneth Vaux, ed., *The Ministry of Vincent Van Gogh in Religion and Art* (Eugene, OR: Wipf & Stock, 2012); and Charles Davidson, *Bone Dead, and Rising: Vincent van Gogh and the Self before God* (Eugene, OR: Cascade, 2011).

The book mentioned in the "For Reflection" section is Viktor Frankl, *Man's Search for Meaning* trans. Ilse Lasch (London: Hodder & Stoughton, 1946). Many later editions are available.

Illumination 20

On the nature and importance of Émile Bernard's art, see the large volume, *Émile Bernard 1868–1941: A Pioneer of Modern Art* (Zwolle: Waanders; Van Gogh Museum, 1990).

See the several passages taken from Bernard's writings describing his relation to Van Gogh scattered through the volume edited by Stein, *Van Gogh: A Retrospective*. See also Leo Jansen, Hans Luitjen, and Nienke Bakker, *Vincent Van Gogh, Painted with Words: The Letters to Émile Bernard* (New York: Rizzoli, 2007).

Rainer Maria Rilke, *Letters on Cezanne*, ed. Clara Rilke, trans. Joel Agee (New York: Farrar, Straus and Giroux, 2002), 82–83.

Illumination 22

See Meyer Shapiro, *Van Gogh* (Garden City, NY: Doubleday, 1980), 15–21.

Illumination 23

For an extended study of the Night Café in Arles and of the imagery of Van Gogh's painting, see Cliff Edwards, *Mystery of the Night Café: Hidden Key to the Spirituality of Vincent van Gogh* (Albany, NY: Excelsior Editions, State University of New York Press, 2009).

Illumination 24

See the several important essays in the exhibition volume for the Art Institute of Chicago exhibition: Gloria Groom, ed., *Van Gogh's Bedrooms* (Chicago: Art Institute of Chicago, 2016).

Patrick Heelan, "Afterword," *Hermeneutic Philosophy of Science, Van Gogh's Eyes, and God*, ed. by Babette Babich (Dordrecht: Kluwer Academic Publishers, 2002).

Illumination 25

See the study of Van Gogh's five versions in oil of the *Berceuse*, or "Cradle-rocker," in Debora Silverman, *Van Gogh and Gauguin: The Search for Sacred Art* (New York: Farrar, Straus and Giroux, 2000), 313–69.

See *Van Gogh Repetitions* (New Haven: Yale University Press in association with the Phillips Collection and the Cleveland Museum of Art, 2013).

Illumination 26

On Van Gogh's illness and time at the asylum, see, for example, essays and documents in Nienke Bakker, Louis van Tilborgh, Laura Prins, Teio Meedendorp, Van Gogh Museum, *On the Verge of Insanity: Van Gogh and His Illness* (Brussels: Mercatorfonds; distributed by Yale University Press, 2016).

Illumination 27

See the recent study by Martin Bailey, *Starry Night: Van Gogh at the Asylum* (London: White Lion, 2018).

Illumination 28

Along with the many books on religion, spirituality, and ecological Christianity by Matthew Fox and Wendell Berry that might be relevant to Van Gogh's nature-centered paintings and parable-inspired passages, see Kristin Swenson, *God of Earth: Discovering a Radically Ecological Christianity* (Louisville: Westminster John Knox, 2016).

On Van Gogh's paintings focused on nature's seasons, wheat fields, and gardens, see Sjraar van Heugten et al., *Van Gogh and the Seasons* (Princeton, NJ: Princeton University Press; Melbourne: National Gallery of Victoria, 2018), and *Van Gogh: Fields*, edited by Wulf Herzogenrath and Dorothee Hansen (Bremen exhibition, Van Gogh Fields, Hatje Cantz Publishers, 2002). Also, see the excellent essays and images in *Vincent van Gogh: Between Earth and Heaven; The Landscapes*, prepared for the exhibition at the Kunstmuseum Basel (Ostfildern: Hatje Cantz, 2009).

Illumination 29

See Natascha Veldhorst, *Van Gogh and Music: A Symphony in Blue and Yellow*, trans. Diane Webb (New Haven: Yale University Press, 2018). Van Gogh can suggest that we need to "live more musically," hopes his *La Berceuse* painting "sings a lullaby in color," and believes his sunflower paintings make of the Yellow House "a symphony in blue and yellow."

The book mentioned at the end of this section is Oliver Sacks, *Gratitude* (New York: Alfred A. Knopf, 2015).

Illumination 30

Van Gogh's admiration for the art and peasant life of Jean-François Millet was a major influence on his own life journey. One of the most important books shaping Vincent's thinking was A. Sensier's *La vie et l'oeuvre de Jean-Francois Millet* (Paris, 1881), now available in reprints from a variety of sources. Numerous letters by Van Gogh describe his love of Millet's art and of his wish to follow the life-path of the peasant-painter as depicted in Sensier's book.

Illumination 31

Van Gogh's struggle to define his own approach to biblical themes in art and his decision to focus on contemporary life over the "medieval tapestries" of Bernard and others are dealt with at some length in Cliff Edwards, *Van Gogh's Ghost Paintings* (Eugene, OR: Cascade Books, 2015).

Illumination 32

For the poem mentioned at the end of this illumination, see Robert Frost, "The Road Not Taken," https://tinyurl.com/ybk47v8e.

Illumination 33

See the previously cited Bakker et al., *On the Verge of Insanity*.

Illumination 35

See the text of George-Albert Aurier's article in the January 1890 *Mercure de France* in Stein, *Van Gogh: A Retrospective*, 181–93.

On Vincent's paintings of shoes and choice of being a "shoemaker" in art, see Cliff Edwards, *The Shoes of Van Gogh* (New York: Crossroad, 2004), particularly chapter 6, "Empty Shoes: A Ghost Story," which tells of Jacques Derrida and Martin Heidegger's views on the painting of *(Old) Shoes* (F255, JH1124).

Illumination 37

On "through a glass, darkly," see, for example, the previously cited Meeks, *The Writings of St. Paul*. There the phrase is translated "now we see in a mirror dimly," and footnote 8 acknowledges that there are many ways ancient authors interpret the "mirror metaphor." Here it is viewed as emphasizing the "indirectness and incompleteness of knowledge in the present world."

Illumination 38

Note the images of these paintings: the "large landscape viewed from a height," and another with "vineyards and meadows in the foreground," and one of "a green field of wheat," all of which can be found on pages 261 and 262 of volume 5 of Jansen, Luijten, and Bakker, *Vincent van Gogh: The Letters*, or at Letter 886 at vangoghletters.org. The careful descriptions of the crops in each field for his sister indicate how significant fields of crops, their arrangement, and their color could be for Vincent, and he hoped they would be so also for those who would see the works. His descriptions are a kind of "litany" or visual hymn to peasants, the earth, and the viewers.

Illumination 40

The descriptions of some of Vincent's last paintings for Theo, Jo, and their child take on deep significance, and the images of these works in volume 5 of *Vincent van Gogh: The Letters* or at vangoghletters.org deserve a careful viewing. Vincent's work as a "peasant painter" continued to the last, and his descriptions now of "Daubigny's garden," "old thatched roofs," and "immense stretches of wheat after the rain" reveal his sense of beauty where human labor and earth's varied gifts meet.

The French satire *Candide* was first published in 1759 by the philosopher François-Marie Arouet, under the pen name Voltaire. It has been widely translated into English and other languages.

Illumination 41

These "discarded" letters placed among the Related Manuscripts at vangoghletters.org reveal the care given by Theo and Jo to Vincent's torn-up or unmailed attempts at letters, and so by the Van Gogh Museum and its collection. These pages, along with Theo's letter to Vincent on July 1, 1890, are a moving example of the anxieties facing Theo, Jo, and Vincent that soon end in the sacrificial suicide of the artist, and the early death through illness of brother Theo. The salvaging of the correspondence and the collection of Vincent's art by Johanna in the midst of her loss, sorrow, and responsibilities for her young child becomes all the more amazing. The gratitude of all who have seen and been moved by Vincent's art and by the context of his second gift, the letters, continues to germinate and blossom through their creative spirit.

See again the previously cited Frankl, *Man's Search for Meaning*.

List of Illustrations

Most of the images in this book are "letter sketches" drawn by Vincent van Gogh on the pages of letters he posted. A few are drawn on separate sheets and enclosed in letters. These can all be seen at vangoghletters.org, on the facsimile "with sketches." The number assigned each sketch by the scholar, Jan Hulsker (JH), is given. All are used with the permission of the Van Gogh Foundation and the Van Gogh Museum in Amsterdam. Illustration listings below are not necessarily in the order in which they appear in this book; rather, they are listed here in chronological order, according to the numbered volumes of *Vincent van Gogh: The Letters*, edited by Leo Jansen, Hans Luijten, and Nienke Bakker, 6 vols. (New York: Thames and Hudson, 2009).

Volume 1

1. Letter sketch: small churches at Petersham and Turnham Green, JH Juv.8, Letter 99, 11/25/1876

2. Enclosed sketch, Cafe au charbonnage, JH Juv.9, Letter 148, 11/13–16/1878

3. Letter sketch, Miners in the snow at dawn, JH Juv.10, Letter 156, 8/20/1880

4. Letter sketches, Road with Pollard willows, JH 48; Farmhouses, JH 49; Letter 173, Oct. 1881

Volume 2

1. Letter sketch, Group of people with fishing boat returning, JH 205, Letter 265, 9/18/1882

2. Letter sketch, Soup distribution in a public soup kitchen, JH 332, Letter 342, 3/4/1883

3. Enclosed sketch, Girl kneeling by a cradle, JH 338, Letter 330, 3/18/1883

4. Letter sketch, Gardener near a gnarled apple tree, JH 380, Letter 362, 7/13/1883

Volume 3

1. Letter sketches, Ploughman, Farm with stacks of peat, JH 422, Letter 396, 10/15/1883

2. Letter sketch, Parsonage garden with trees in blossom, JH 476, Letter 444, April 1884

3. Letter sketch, Wheat harvest, JH 508, Letter 453, 8/4/1884

4. Letter sketch, The potato eaters, JH 735, Letter 492, 4/9/1885

5. Letter sketch, Bird's nest, JH 943, Letter 533, 10/4/1885

6. Letter with sketch, Head of a Woman (Gordina de Groot), JH 784, Letter 505, 5/28/1885

Volume 4

1. Letter sketch, Three orchards, JH 1393, Letter 597, 4/13/1888

2. Letter sketch, The Yellow House, JH 1413, Letter 602, 5/1/1888

3. Letter sketches, Farmhouse in wheatfield; View of Arles, JH 1418, Letter 609, 5/12/1888

4. Letter sketch, Cicada, JH--, Letter 638, 7/10/1888

5. Letter with sketch, Sower with Setting Sun. JH 1628, Letter 722, 11/21/1888

Volume 5

1. Letter sketch, Trees with ivy in Asylum garden, JH 1694, Letter 776, 5/23/1889

2. Letter sketch, The raising of Lazarus (after Rembrandt), JH 1973, Letter 866, 5/2/1890

3. Letter sketches, Girl against wheat background, Couple walking between poplars, Wheatfields, JH 2042, Letter 896, 7/2/1890

4. Letter sketch, Daubigny's garden, JH 2106, Letter 902, 7/23/1890

5. Letter sketch, Thatched cottages and figures, JH 2116, Letter 902, 7/23/1890

Other

1. Sketch, La Crau Seen from Montmajour, Arles, JH 1501, July 1888